IMAGES
of Modern America

THE SPACE SHUTTLE
ENDEAVOUR

IMAGES
of Modern America

THE SPACE SHUTTLE
ENDEAVOUR

Stephen Hayward Silberkraus

ARCADIA
PUBLISHING

Published by Arcadia Publishing
Charleston, South Carolina

Printed in the United States of America

Library of Congress Control Number: 2013951096

For all general information, please contact Arcadia Publishing:
Telephone 843-853-2070
Fax 843-853-0044
E-mail sales@arcadiapublishing.com
For customer service and orders:
Toll-Free 1-888-313-2665

Visit us on the Internet at www.arcadiapublishing.com

For Sawyer.

CONTENTS

ACKNOWLEDGMENTS

Over the course of the last few years, there have been many individuals and organizations that have been kind enough to help me with my documentary work. First and foremost, I must thank the National Aeronautics and Space Administration (NASA) for allowing me access and giving me support while documenting *Endeavour* and her fellow shuttles. Moreover, I would like to especially thank the following individuals at NASA for their personal support: Bartholomew Pannullo, Deborah Awtonomow, Jeff Moore, Guy Noffsinger, Richard Brewer, William Carr, Ken Thornsley, Lisa Fowler, the firefighters at Kennedy Space Center (KSC), Jennifer Horner, F. Robert Smith, and Charles F. Romeo.

I would also like to thank the California Science Center, the Society of Camera Operators, and the following individuals: Jeffrey N. Rudolph, Haley Jackson, Christopher Gabriel, Jeannie D. Neill, Fred Silberkraus, Melissa Eccles, Victor Hernandez, Chuck Null, Chelyn Sawyer, Chris Tufty, Jessica Jurges, Mark August, Dave Frederick, Don Wright, David Knight, Tom Lanny, Nicole Fleit, Rachel Lippert, Ralph Burris, Steve Blair, Steve Soboroff, Wiliam T. Harris, Jason Knight, Ken Phillips, Jeremy Sultan, Dan Kneece, Nicolas Levene, and Haskell Wexler.

And lastly, thank you to my family for their support and encouragement; I would be nothing without them.

INTRODUCTION

Born out of tragedy and like none of its predecessors, Space Shuttle *Endeavour* would go on to perform many vital and historical missions for humanity over the course of her 25 missions and 19-year career.

After the devastating *Challenger* disaster in 1986, there was hope for a new and improved Space Shuttle orbiter. When Congress gave authorization, serious consideration was given to refitting the test orbiter *Enterprise* (OV-101). Due to cost and time requirements, this was quickly turned down; it was far cheaper and faster to build a new orbiter. So, using structural spares created during the construction of *Discovery* and *Atlantis*, construction of NASA's newest (and last) orbiter began in February 1982.

Initially cobbled together from leftovers, this phoenix rose high and strong to become a ship that would inspire pride and admiration. As a lasting legacy, *Endeavour* would not only begin constructing the International Space Station (ISS), but would also be the orbiter to complete the US segment assembly.

Named through a national competition of students, *Endeavour* pays homage to Captain Cook's HMS *Endeavour*, the discoverer of new lands, including the Hawaiian islands. Astronomers on board Cook's *Endeavour* calculated Earth's distance from the sun, establishing the value of scientists on voyages of discovery. Furthermore, the name also recognizes the command module of Apollo 15.

Space Shuttle *Endeavour* never failed in her mission to expand humanity's knowledge of space. She took the world to new, unimagined territories with revelations about the planet and helped bring to reality the International Space Station.

At her first launch, on May 7, 1992, she was equipped with state-of-the-art equipment. When the solid rocket boosters ignited, *Endeavour* was transported into history along with her seven-member crew, rendezvousing with the Intelsat VI satellite stranded in low Earth orbit when a Titan rocket launch system failed to place it in its correct orbit. After three attempts with three crew members, a bar was attached, a live rocket-engine kit installed, and the satellite was released into orbit. It was a record-making mission: the first where an Extra Vehicular Activity (EVA) involved three people, and the first time a live rocket kit was attached to a satellite in space during an EVA. The first mission to feature four EVAs, it was the longest single Space Shuttle mission at the time (25 hours and 27 minutes) and the longest maiden voyage of five operational shuttle orbiters (8 days, 21 hours, 17 minutes, and 38 seconds). Over her history, there were a myriad of achievements and records.

STS-47 was the first on-time launch since November 1985; it also marked the first time a Japanese astronaut flew aboard the Space Shuttle and the first flight of an African American woman and of a married couple.

STS-61 was the first Hubble Space Telescope servicing mission, revitalizing Hubble and correcting its vision. After a record five back-to-back space walks, Hubble's altitude was raised by *Endeavour* with a series of two thruster firings. *Endeavour* redeployed Hubble into Earth's orbit to again beam

crystal clear images of the cosmos back to Earth. This mission carried the highest-percentage risk of catastrophic failure ever given—1 in 150.

A permanent, space-based work platform had always been a goal for NASA, so STS-88 was arguably the second of *Endeavour's* two most important missions, taking an International Space Station from planning to reality being the most important. Now *Endeavour's* role would be in scientific achievements in low Earth orbit and international cooperation. Construction of the ISS began in December 1998. Over 12 days, the crew mated the Unity module to OV-105's Orbiter Docking System (ODS) on FD-3, rendezvoused with and grappled the Zarya module on FD-4, and conducted two spacewalks to successfully connect power and data cables.

Endeavour's missions collected a trillion measurements of Earth's topography to create better maps, enhance water drainage modeling, make more realistic flight simulation, improve the search for cell phone tower locations, and enhance navigation safety. Over the course of 222 hours of mapping, her radar images filled 332 high-density tapes, covered 99.98 percent of the planned mapping area at least once, and 94.6 percent of it twice. She compiled enough data to fill 20,000 CDs.

Her 15th mission, STS-97, was the 101st Space Shuttle mission and the last manned spaceflight of the 20th century. She was the first to visit the populated ISS, and the first shuttle mission, STS-108, to launch after the attacks on September 11, 2001. *Endeavour* carried with her into space a tattered American flag from ground zero, memorabilia of fallen NYPD and FDNY personnel, and a myriad of commemorative flags. Aboard for his first space flight was pilot Mark E. Kelly, the man who would be the final commander of *Endeavour* on the upcoming launch of STS-134.

Endeavour's final flight was awe inspiring, delivering the final round of external spare parts for the ISS and the Alpha Magnetic Spectrometer-02 (AMS-02). This will spend the next decade conducting observations of the universe, seeking evidence of and information on dark matter, dark energy, and antimatter. This mission saw the final spacewalk by a Space Shuttle crew, the final flight of an international astronaut on the Space Shuttle, and the final all-male crew of a Space Shuttle mission. This was the 134th Space Shuttle mission, the 165th manned US spaceflight, and the 25th flight of *Endeavour*, her 12th to the ISS.

Upon her return, *Endeavour* was retired; her Shuttle Remote Manipulator System (robot arm) was removed and sent back to Canada to be displayed at a museum to highlight Canada's contributions to the Space Shuttle program.

In a final victory flight atop the Shuttle Carrier Aircraft, *Endeavour* was flown piggyback across the United States. Welcomed and waved along by thousands of admirers, she finally arrived in Los Angeles, California, the state where she was built. OV-105 *Endeavour* will be permanently displayed as the centerpiece of a newly planned space exhibit at the California Science Center in Los Angeles.

Long may she inspire.

One

BUILDING A SHUTTLE

Like none other before, NASA's newest (and last) orbiter was cobbled together from leftovers and structural spares created during the construction of *Discovery* and *Atlantis*. But *Endeavour* would ultimately receive technical upgrades to make her the most advanced of all. This is the story of a phoenix rising higher and stronger to become a ship that would inspire pride and admiration. (Courtesy of NASA.)

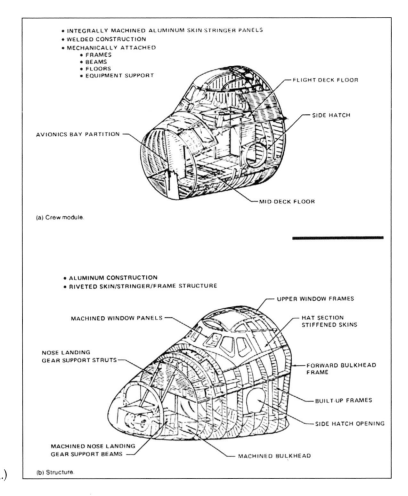

- INTEGRALLY MACHINED ALUMINUM SKIN STRINGER PANELS
- WELDED CONSTRUCTION
- MECHANICALLY ATTACHED
 - FRAMES
 - BEAMS
 - FLOORS
 - EQUIPMENT SUPPORT

FLIGHT DECK FLOOR

SIDE HATCH

AVIONICS BAY PARTITION

MID DECK FLOOR

(a) Crew module.

- ALUMINUM CONSTRUCTION
- RIVETED SKIN/STRINGER/FRAME STRUCTURE

MACHINED WINDOW PANELS

UPPER WINDOW FRAMES

HAT SECTION STIFFENED SKINS

NOSE LANDING GEAR SUPPORT STRUTS

FORWARD BULKHEAD FRAME

BUILT-UP FRAMES

SIDE HATCH OPENING

MACHINED NOSE LANDING GEAR SUPPORT BEAMS

MACHINED BULKHEAD

(b) Structure.

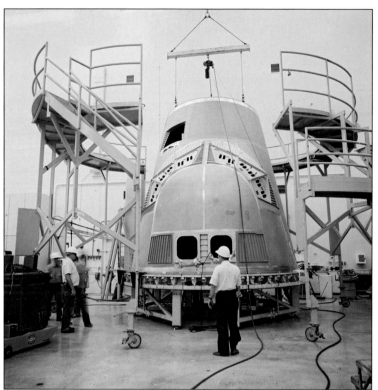

Rockwell employees take time to inspect *Endeavour's* crew module during construction in Building 290 at the Rockwell Downey facility on July 18, 1986. (Courtesy of Boeing.)

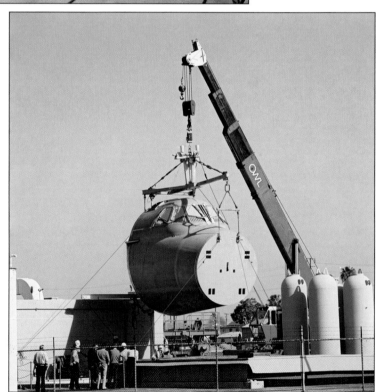

In this January 20, 1987, image, *Endeavour's* crew module is being lowered into the vacuum chamber test facility at Rockwell's Downey facility. (Courtesy of Boeing.)

The shuttle's vertical tail was delivered to Rockwell from Fairchild, New York, on September 18, 1987. (Courtesy of Boeing.)

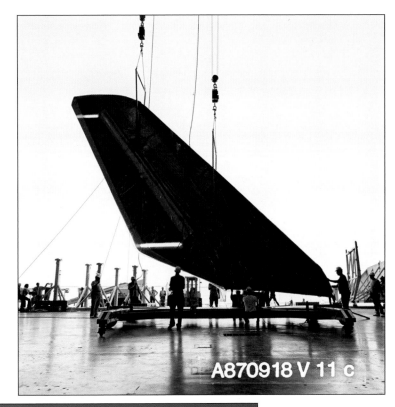

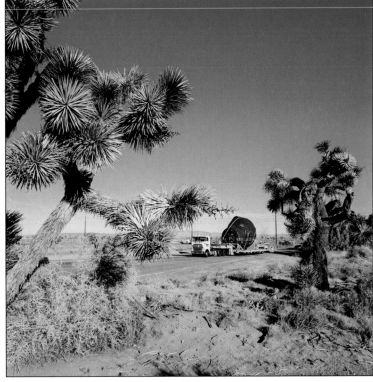

A truck carries its valuable cargo, the forward fuselage/crew module, on a desert journey through Joshua Tree National Park in California. The truck, seen here on February 23, 1990, is destined for the Rockwell Palmdale facility. (Courtesy of Boeing.)

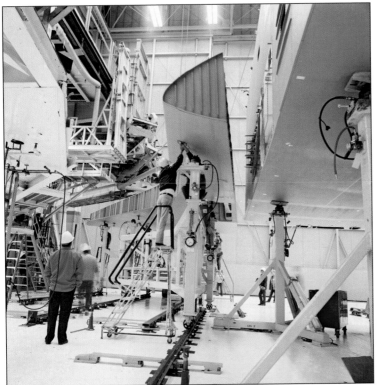

Workers watch at Rockwell's Palmdale facility as the left wing is positioned for installation onto the mid-fuselage on February 19, 1988. (Courtesy of Boeing.)

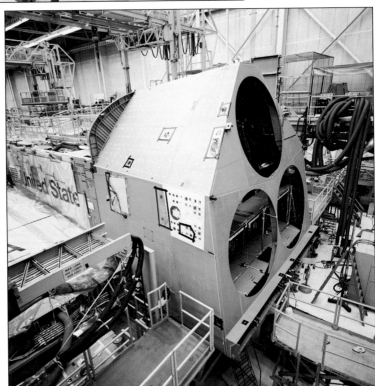

The aft fuselage was being installed onto the mid-fuselage on December 20, 1989. This took place at Rockwell's Palmdale facility. (Courtesy of Boeing)

Rockwell Downey workers pay careful attention during the liquid Hydrogen (LH$_2$) and liquid Oxygen (LO$_2$) manifolds installation in the aft fuselage on August 2, 1989. (Courtesy of Boeing.)

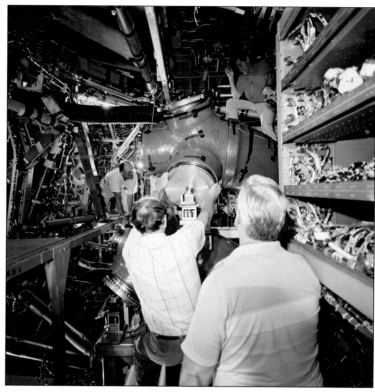

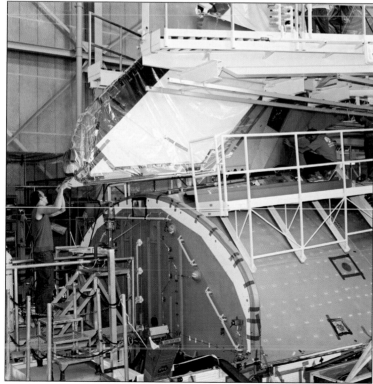

The vertical tail is being installed in the Rockwell Palmdale facility on August 27, 1990. (Courtesy of Boeing.)

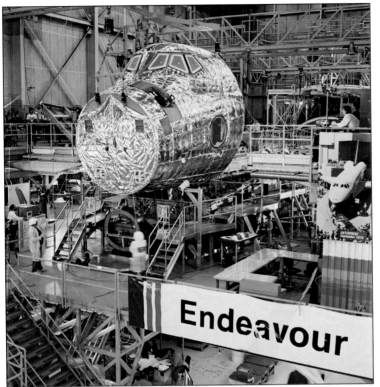

The forward fuselage/crew module is being installed during construction at the Rockwell Palmdale facility on February 28, 1990. (Courtesy of Boeing.)

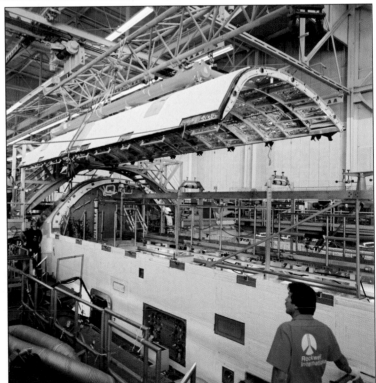

This image shows the payload bay doors being installed in the Rockwell Palmdale facility on September 9, 1990. (Courtesy of Boeing.)

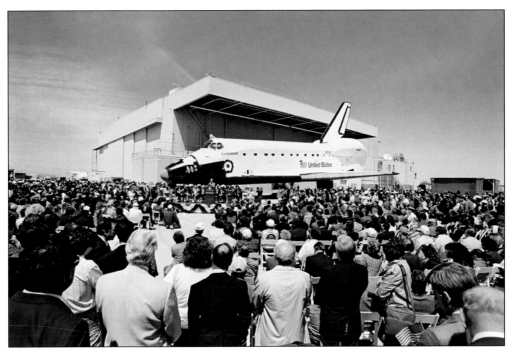

OV-105 *Endeavour* is being rolled out after the build at Rockwell's Palmdale facility. Her completion was celebrated with great fanfare on April 25, 1991. (Courtesy of Boeing.)

On May 1, 1991, OV-105 *Endeavour* was attached to the Shuttle Carrier Aircraft (SCA), a modified Boeing 747, at Rockwell's Palmdale facility so that it could be flown to the Kennedy Space Center (KSC) in Florida. (Courtesy of Boeing.)

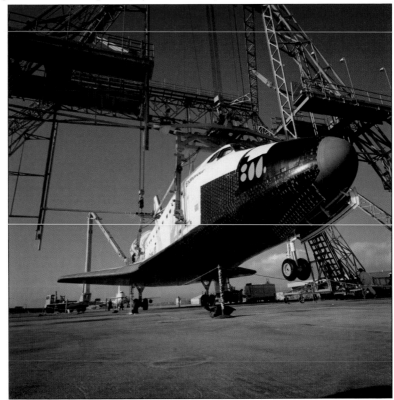

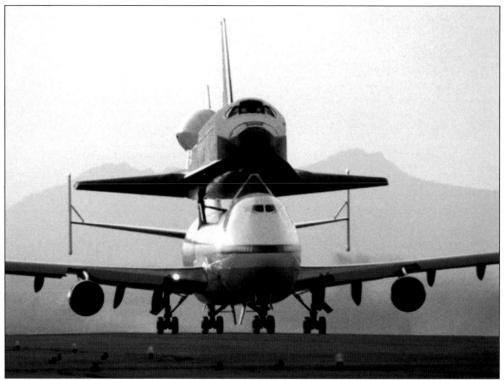

NASA's 747 SCA No. 911, the Space Shuttle *Endeavour* securely mounted atop its fuselage, taxis to the runway to begin the flight from Rockwell's Plant 42 in Palmdale, California, to KSC in Florida. (Courtesy of NASA.)

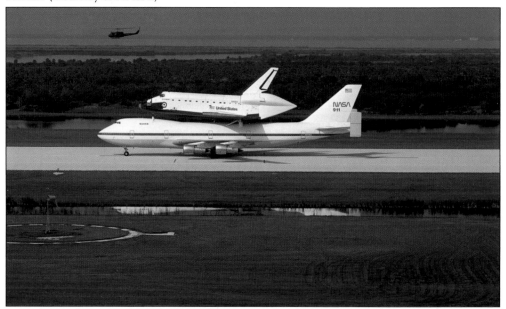

The newest addition to NASA's Space Shuttle fleet arrives at the KSC aboard the 747 Shuttle Carrier Aircraft on May 7, 1991. *Endeavour*'s first launch, the STS-49 mission, began with a flawless liftoff exactly one year later on May 7, 1992. (Courtesy of NASA.)

Two

THE MAIDEN FLIGHT

On May 7, 1992, *Endeavour* and her seven-member crew were transported into history. Rendezvousing with the Intelsat VI satellite, which was stranded in low Earth orbit, it was the first mission to feature four EVAs and to use a drag chute for landing. The longest maiden voyage of the five shuttle orbiters (8 days, 21 hours, 17 minutes, and 38 seconds), it was a record-making mission, marking the first time that a live rocket kit was attached to a satellite in space during an EVA and the first to involve three people with an EVA. This STS-49 mission patch was designed by the crew. (Courtesy of NASA.)

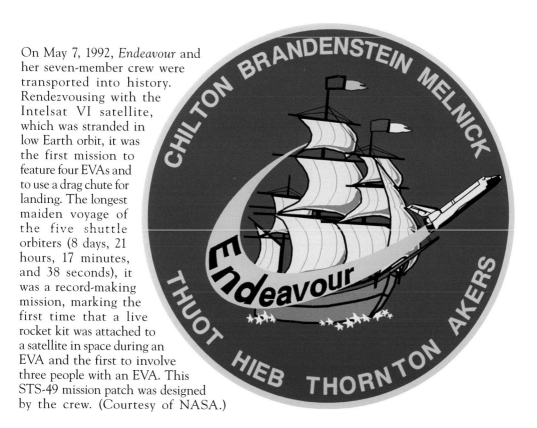

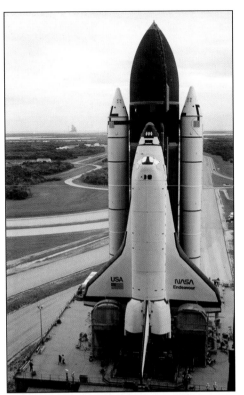

In this March 13, 1992, photograph, the Space Shuttle *Endeavour* rolls out of the Vehicle Assembly Building and heads to Launch Pad 39B in preparation for its maiden voyage. (Courtesy of NASA, Marshall Space Flight Center.)

On May 7, 1992, STS-49, the first mission of the Space Shuttle *Endeavour*, gets underway as the shuttle lifts off from launch pad 39B. The mission was the first flight involving three crew members working outside the spacecraft simultaneously. (Courtesy of NASA, Marshall Space Flight Center.)

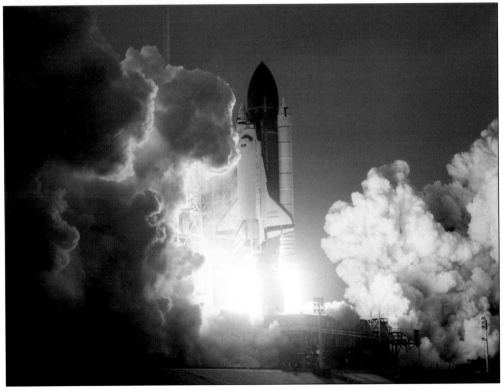

This image, taken from *Endeavour's* aft flight deck windows, shows the first single-EVA capture attempt of the Intelsat VI. Mission specialist Pierre Thuot attempts to attach the satellite capture bar to the free-floating communications satellite. (Courtesy of NASA, Marshall Space Flight Center.)

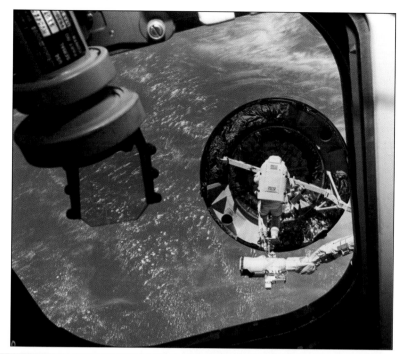

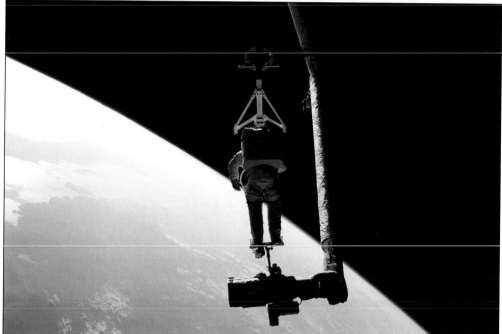

Astronaut Pierre J. Thuot, an STS-49 mission specialist, can be seen during a second extravehicular activity, his feet attached to a portable foot restraint on the remote manipulator system end effector. He waits with a special grapple bar for *Endeavour* to rendezvous with the Intelsat VI communications satellite. Despite the crew's best efforts, the second attempt to capture the 4.5-ton satellite failed; two days later, however, the three crew members returned and successfully captured the satellite. (Courtesy of NASA, Marshall Space Flight Center.)

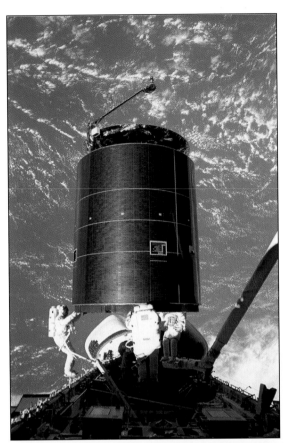

These two photographs show the successful capture of the Intelsat VI satellite. From left to right are astronauts Richard J. Hieb, Thomas D. Akers, and Pierre J. Thuot, all with handholds on the satellite. These images were among the first NASA released from the STS-49 mission. (Both, courtesy of NASA, Marshall Space Flight Center.)

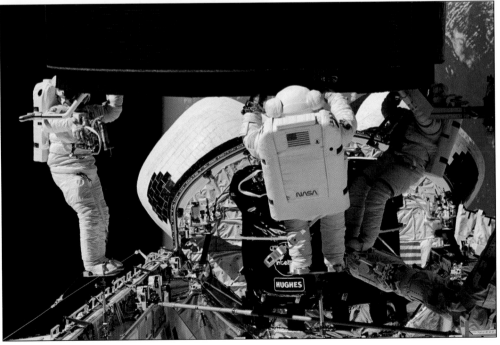

Developed by Marshall Space Flight Center, the Mission Peculiar Equipment Support Structure (MPESS), designed to store energy for portable electronic devices, supports experiments in space. Here astronaut Thomas Akers is in the cargo bay, positioned near the MPESS. (Courtesy of NASA, Marshall Space Flight Center.)

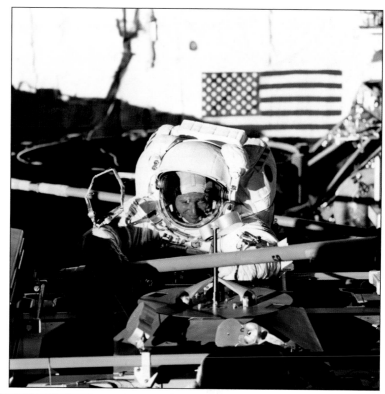

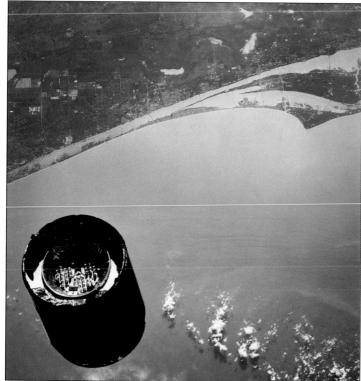

Florida's Atlantic coast and the Cape Canaveral area can clearly be seen in this image. This photograph was taken from onboard *Endeavour* and shows the INTELSAT VI. (Courtesy of NASA, Marshall Space Flight Center.)

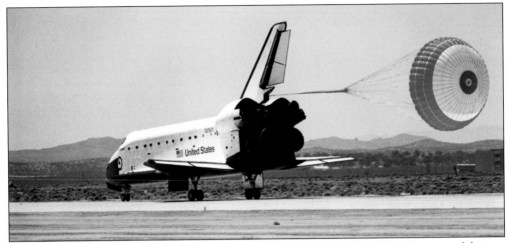

Endeavour landed at Edwards Air Force Base on May 16, 1992, ending STS-49's successful nine-day mission dedicated to the retrieval, repair, and redeployment of the INTELSAT VI satellite. During this landing *Endeavor* was the first to use a drag chute to reduce brake wear and shorten landing distance. (Courtesy of NASA, Marshall Space Flight Center.)

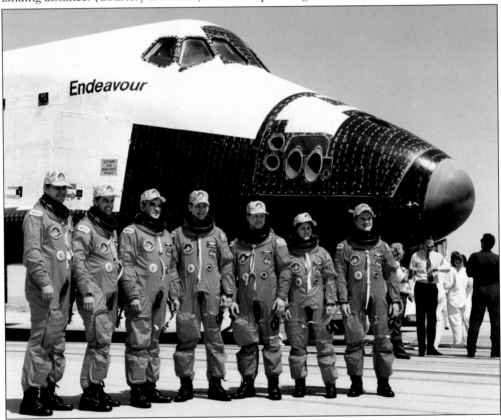

The STS-49 crew members pose near *Endeavour* after landing in California. From left to right are Richard J. Hieb, mission specialist; Kevin P. Chiltin, pilot; Daniel C. Brandenstein, commander; and mission specialists Thomas D. Akers, Pierre J. Thuot, Kathryn C. Thornton, and Bruce E. Melnick. (Courtesy of NASA, Marshall Space Flight Center.)

Three

TWENTY YEARS OF MISSION

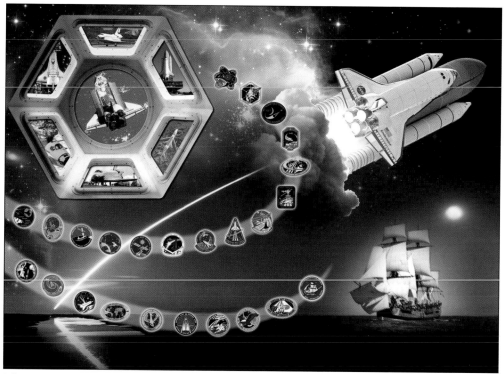

This commemorative poster reflects *Endeavour's* many accomplishments, including saving the Hubble Space Telescope, collecting over a trillion measurements of Earth's topography to create better maps, enhancing water drainage modeling, aiding realistic flight simulation, improving the search for cell phone tower locations, and improving navigation safety. But above all this, she gave birth to the International Space Station, to which half of her life was devoted. (Courtesy of NASA.)

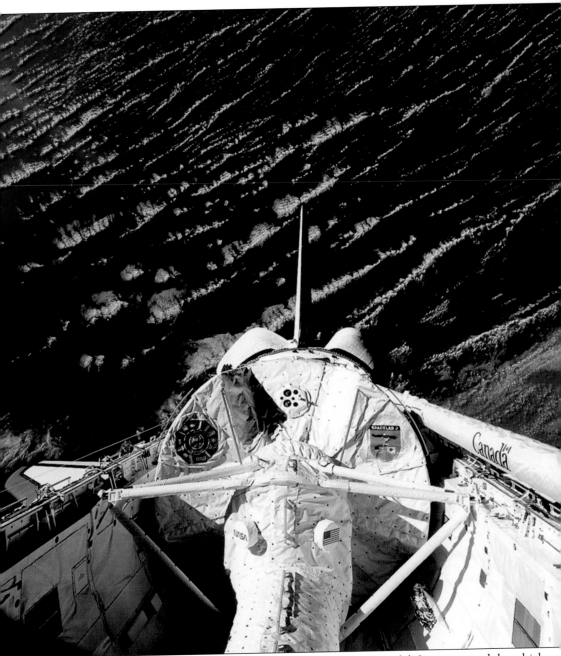

Part of the payload bay of Space Shuttle *Endeavour* and the Spacelab-J science module, which housed numerous scientific experiments during the STS-47 nine-day mission, can be seen here. The backdrop to this September 20, 1992, image shows the Indian Ocean and the southern coast of Somalia with rows of cirrocumulus clouds visible over the ocean. (Courtesy of NASA.)

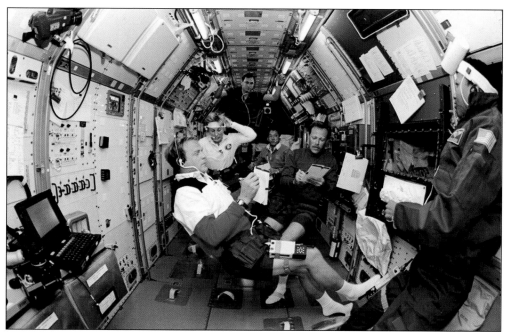

Six of the crew members share the changeover in Spacelab-Japan. Taken in September 1992, this image shows mission specialist Mae Jemison in the foreground at right; beyond her are payload commander Mark C. Lee, commander Robert "Hoot" Gibson, mission specialist and pilot N. Jan Davis, pilot Curtis L. Brown, and payload specialist Mamoru Mohri. (Courtesy of NASA.)

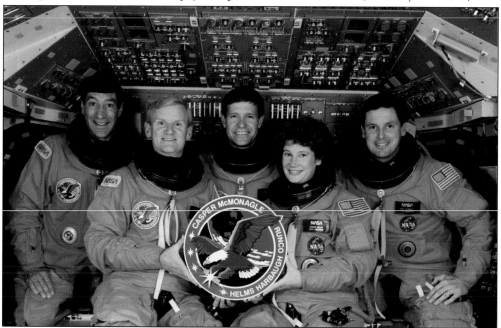

The STS-54 crew poses for a portrait. The crew launched aboard the Space Shuttle *Endeavour* on January 13, 1993. From left to right are Mario Runco Jr., mission specialist; John H. Casper, commander; Donald R. McMonagle, pilot; and mission specialists Susan J. Helms and Gregory J. Harbaugh. (Courtesy of NASA.)

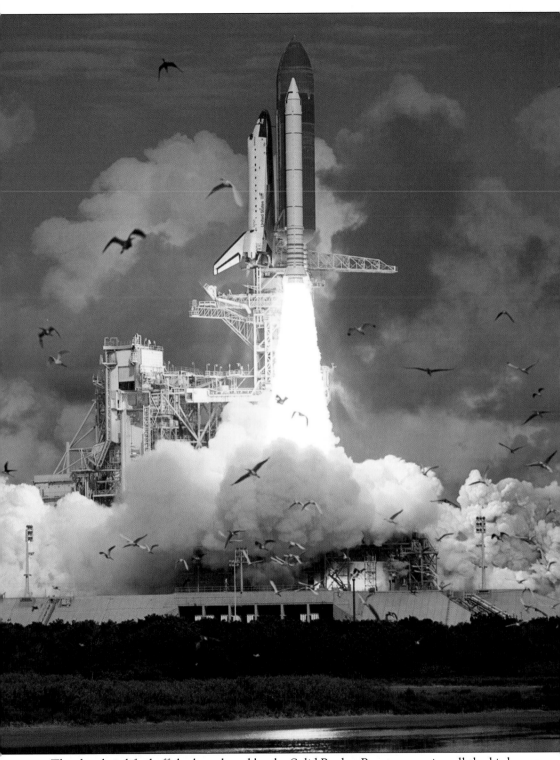

The shuttle is lifted off the launch pad by the Solid Rocket Boosters, scaring all the birds away. (Courtesy of NASA.)

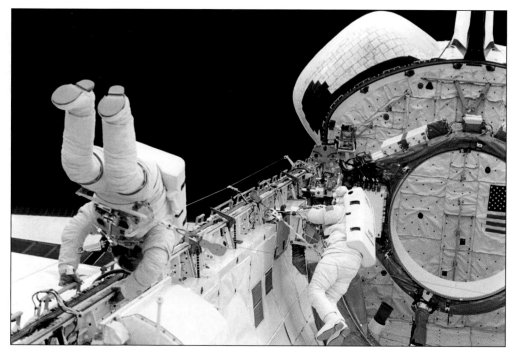

Gregory J. Harbaugh and Mario Runco Jr., wearing a red-striped extravehicular mobility unit, work together during the EVA on the STS-54 mission. (Courtesy of NASA.)

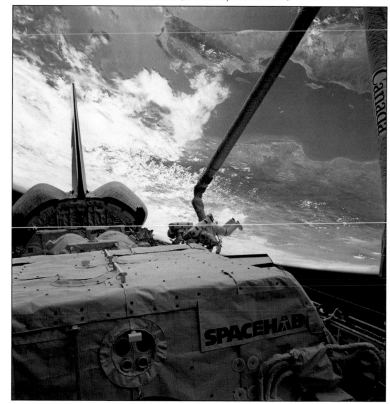

The Spacehab module can be seen in the foreground. Nancy Sherlock controls the Remote Manipulator System (RMS) robotic arm, while astronauts David Low and Jeff Wisoff are maneuvered around *Endeavour's* payload bay. (Courtesy of NASA.)

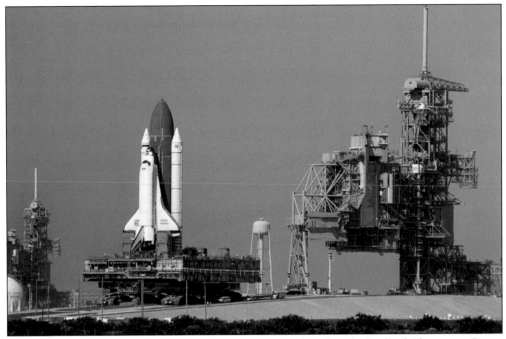

A pad switch became necessary after contamination was found in the Payload Changeout Room at Pad A. Here, the Space Shuttle is rolled around from Launch Pad 39A to Launch Pad 39B. The transfer began around noon and took about seven hours to complete. The payloads for the upcoming STS-61 mission, the first servicing of the Hubble Space Telescope, have yet to arrive. (Courtesy of NASA.)

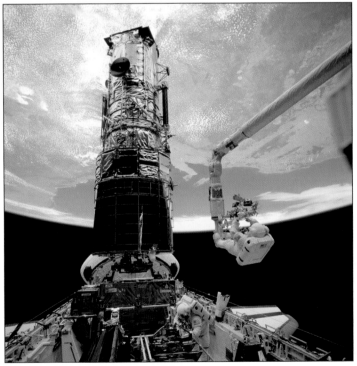

Astronaut F. Story Musgrave, tethered to the end of the RMS arm, readies himself as he is about to be lifted to the top of the Hubble Space Telescope to install protective covers on the magnetometers. Jeffrey A. Hoffman assists Musgrave with final servicing tasks on the telescope in the payload bay, finishing up five days of space walks. (Courtesy of NASA.)

At 7:05 a.m. on April 9, 1994, *Endeavour* lifted off from Launch Pad 39A, starting the nine-day STS-59/Space Radar Laboratory mission. The mission clock, which gives the time into the mission after liftoff, can be seen. (Courtesy of NASA.)

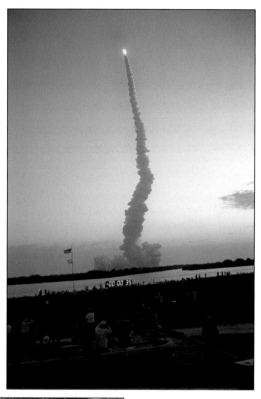

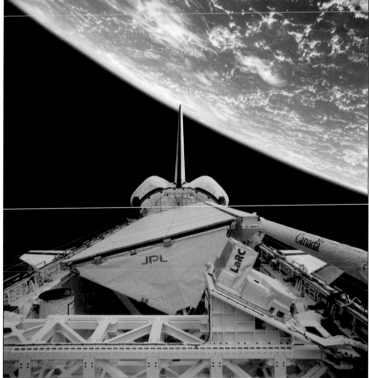

With the Indian Ocean far below, the darkness of space outlines the backdrop for the shuttle's cargo bay. The Space Radar Laboratory (SRL-2) MPESS is visible at the bottom, as are other experiments, including the device for measurement of air pollution from satellites, the antenna for the Spaceborne Imaging Radar, and the X-band Synthetic Aperture Radar. (Courtesy of NASA.)

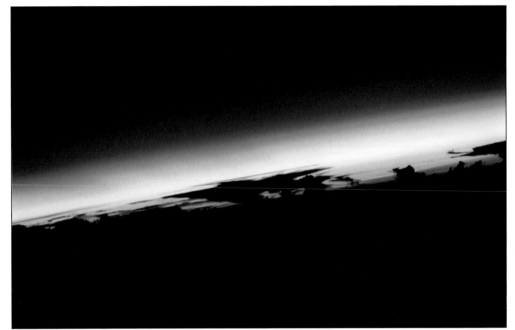

The STS-68 crew told an audience at Johnson Space Center that this sunrise was one of the most scenic sunrises or sunsets witnessed during the Space Radar Laboratory (SRL-2) mission. Clouds and the dawn colors are seen between the blue airglow and the silhouetted horizon of Earth. (Courtesy of NASA.)

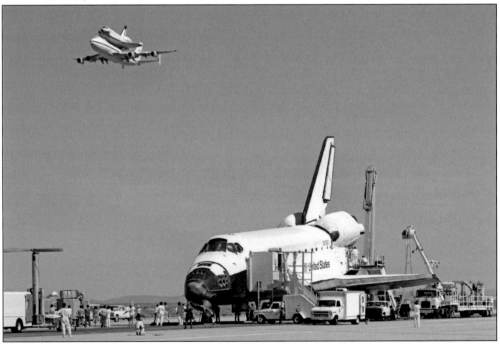

Shortly after mission STS-68 was completed with *Endeavour's* landing on October 12, 1994, at Edwards AFB in California, she received a high-flying salute from her sister shuttle, *Columbia*, seen here atop NASA's Shuttle Carrier Aircraft. (Courtesy of NASA.)

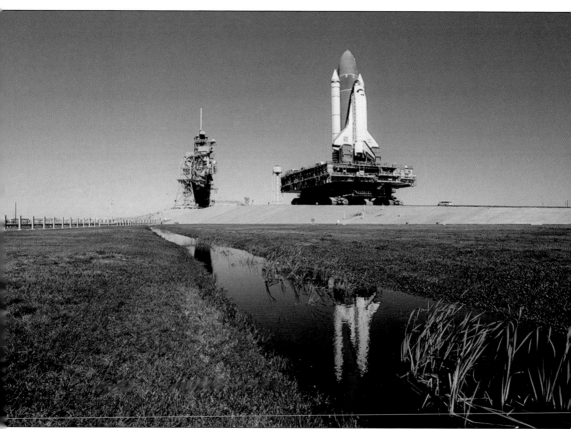

The 16-day STS-67 was to be the longest shuttle flight to date. Weighing 19 million pounds, the Space Shuttle, along with its support and transport hardware, inches toward Launch Pad 39A. The fully assembled *Endeavour* weighs about 4.5 million pounds without its payload. The mobile launch platform, where it was stacked and from where it will lift off, weighs 9.25 million pounds, while the crawler-transporter carrying the platform and shuttle is around 6 million pounds. The primary payload for STS-67 was the Astro-2 astrophysics observatory, which carried three ultraviolet telescopes that flew on the Astro-1 mission in 1990. (Courtesy of NASA.)

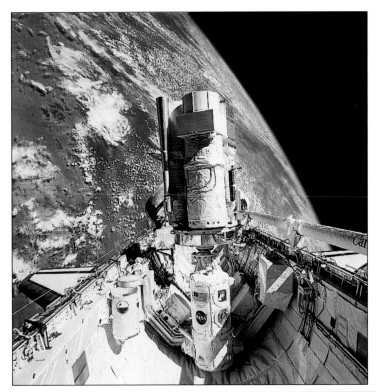

Holding three instruments—the Hopkins Ultraviolet Telescope, the Ultraviolet Imaging Telescope, and the Wisconsin Ultraviolet Photo-Polarimeter Experiment—Astro-2 was the second Spacelab mission to perform astronomical observations in the ultraviolet spectra. (Courtesy of NASA, Marshall Space Flight Center.)

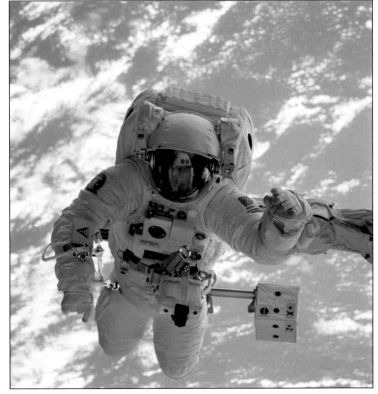

Against the backdrop of Earth, astronaut Michael Gernhardt is seen attached to the shuttle's robot arm during a spacewalk on the STS-69 mission. Unlike earlier spacewalking astronauts, Gernhardt was able to use an electronic cuff checklist, a prototype developed for the assembly of the International Space Station. (Courtesy of NASA.)

In this image, the Wake Shield Facility drifts away from the shuttle; it was earlier released by *Endeavour's* RMS. In the lower left is the coast of Somalia. (Courtesy of NASA.)

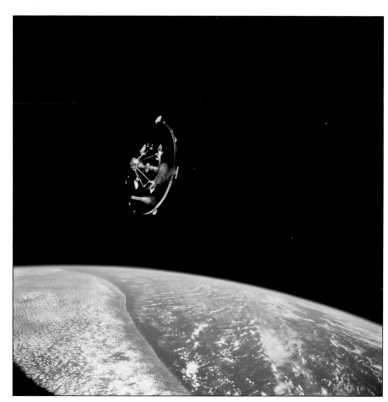

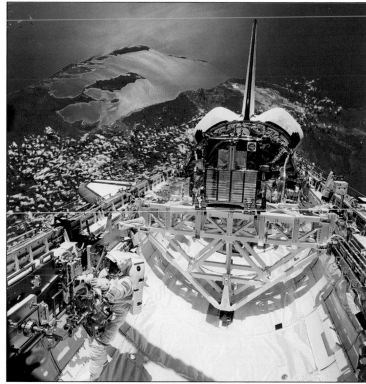

Shark Bay, Australia, is in the background as Leroy Chiao works in the payload bay of *Endeavour* during STS-72. The OAST-Flyer satellite is in the cargo bay. (Courtesy of NASA.)

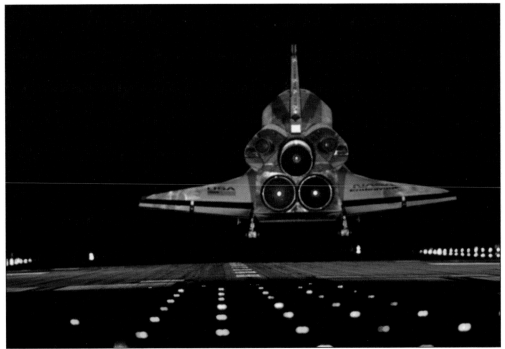

After nine days in space, *Endeavour's* crew landed at Kennedy Space Center's Shuttle Landing Facility. While this was only the third night landing at KSC, it was the eighth night landing for the shuttle program. (Courtesy of NASA.)

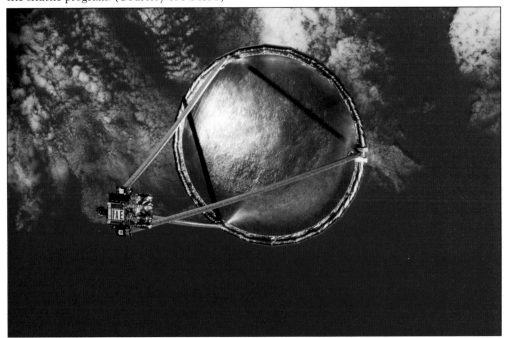

The Inflatable Antenna Experiment was a NASA experiment that began on May 19, 1996, and consisted of an inflatable antenna made of mylar. This experiment was launched from *Endeavour* during STS-77 in cooperation with the satellite Spartan-207. (Courtesy of NASA.)

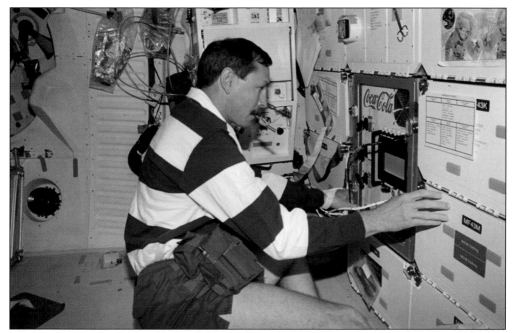

Pilot Curtis Brown places a plastic Coke bottle in the dispenser portion of the Coca-Cola soda module to receive a sample of the carbonated beverage, activating the dispenser better known as the Fluids Generic Bioprocessing Apparatus 2. This was located on *Endeavour's* mid-deck. (Courtesy of NASA.)

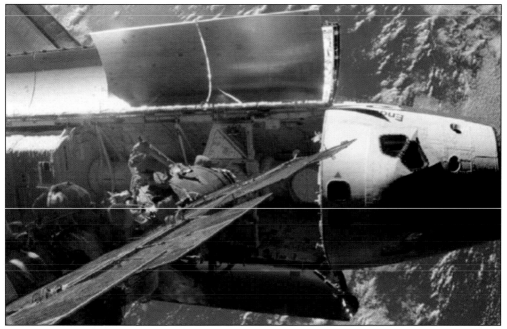

Though it was the eighth of nine planned missions to Mir, the January 1989 STS-89 mission was only the fifth to involve the transfer of US astronauts. In this image, *Endeavour* is docked to Mir during its only visit to the space station. Astronaut David Wolf, who had been on Mir since late September 1997, was replaced by astronaut Andrew Thomas. (Courtesy of NASA.)

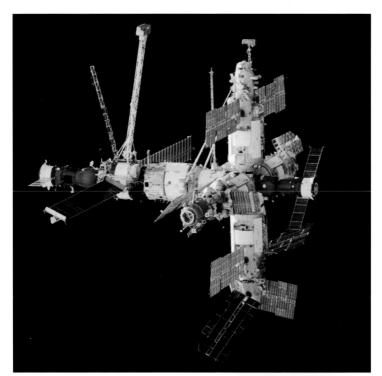

The Mir space station is seen in this image, taken from *Endeavour* during the STS-89 rendezvous. On the right is a Soyuz manned spacecraft; a Progress cargo ship is on the left. (Courtesy of NASA.)

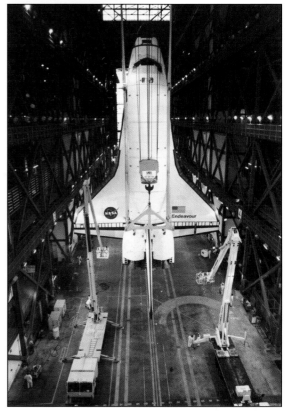

In this December 3, 1998, image, *Endeavour* is scheduled to fly on STS-88, the first shuttle flight for the assembly of the International Space Station (ISS). *Endeavour* is suspended inside the Vehicle Assembly Building and is about to be attached to its solid rocket boosters and external tank. The mission's primary payload is the Unity Connecting Module, which will be attached to the Russian-built Zarya Control Module, already in orbit at that time. (Courtesy of NASA.)

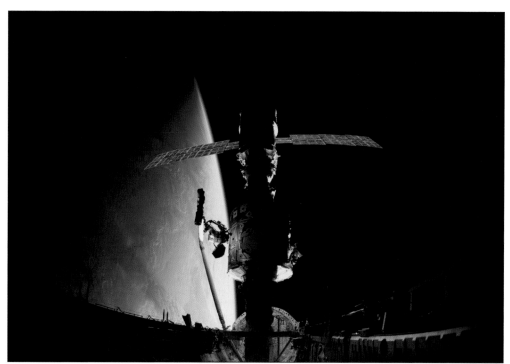

The joining of the US-built Unity node (bottom portion) and the Russian-built Zarya module (top portion) kicked off the *Endeavour* crew's construction of the ISS. (Courtesy of NASA.)

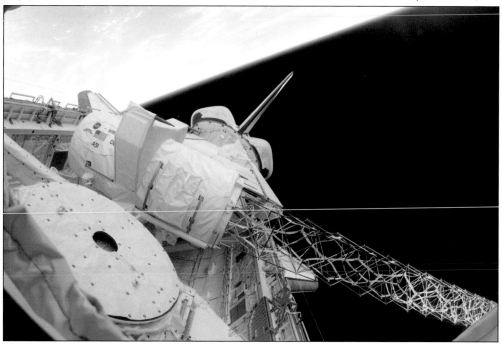

This image shows a section of the Shuttle Radar Topography Mission hardware as seen through *Endeavour's* aft flight deck windows during the SRTM flight. Partially visible at lower right is the mast, which is 200 feet in length. (Courtesy of NASA.)

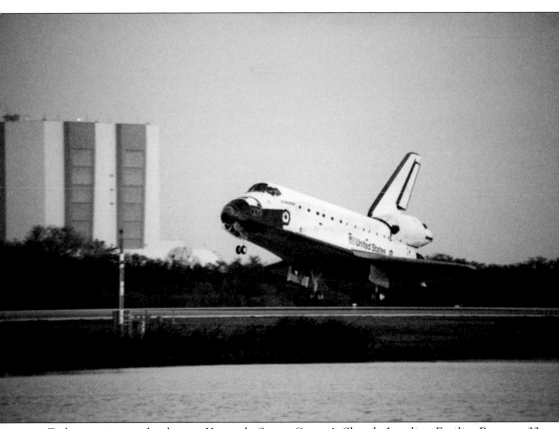

Endeavour is seen landing at Kennedy Space Center's Shuttle Landing Facility Runway 33, completing the STS-99 mission, which lasted 11 days, 5 hours, and 38 minutes. During this mission (the Shuttle Radar Topography Mission) the crew mapped more than 47 million square miles of the Earth's surface. (Courtesy of NASA.)

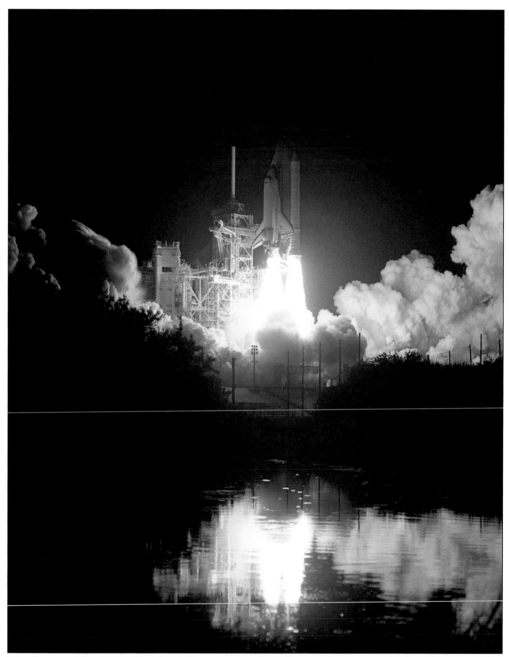

The flames of the Space Shuttle *Endeavour* are reflected in nearby water as it lifts off on November 30, 2000. The five-member STS-97 mission's primary objective was the delivery, assembly, and activation of the US electrical power system onboard the International Space Station. The P6 Integrated Truss Segment was a 17-ton package, the heaviest and largest element yet delivered to the station aboard a Space Shuttle. The electrical power system, which is built into a 240-foot-long solar array structure, is comprised of solar arrays, radiators, batteries, and electronics and eventually provided the power necessary for the first ISS crews to live and work in the US segment. (Courtesy of NASA.)

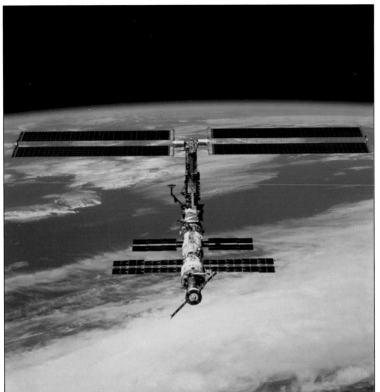

Shown here is one of the first photographs of the entire station with its new solar array panels deployed after the shuttle had been docked to the station for 6 days and 23 hours. With pilot Michael J. Bloomfield at the controls, *Endeavour* moved away from the station and began a tail-first circle about 500 feet away. During the maneuver, which took about an hour, the two spacecraft were moving at five miles per second and traveled about two-thirds of the way around the Earth. (Courtesy of NASA.)

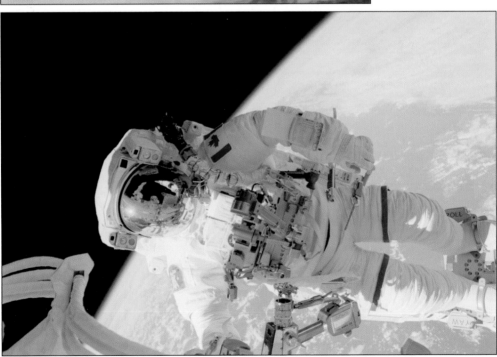

Mission specialist Chris A. Hadfield, who represented the Canadian Space Agency, is seen on the portable foot restraint while connected to *Endeavour's* robotic arm. (Courtesy of NASA.)

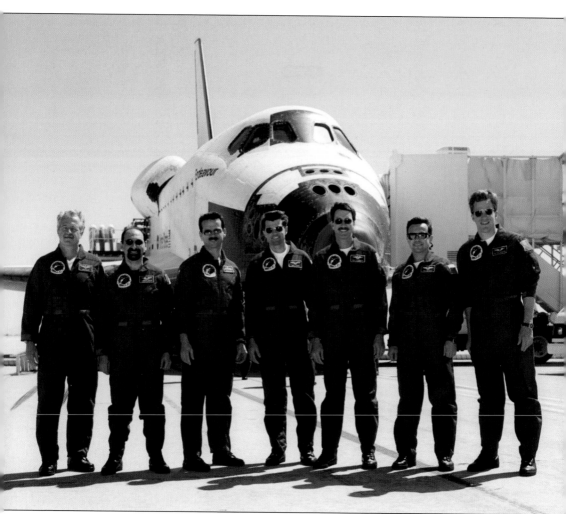

After *Endeavour* completed her STS-100 mission by touching down at Edwards AFB at 9:11 a.m. on May 1, 2001, her six astronauts and one cosmonaut posed with their "home away from home." From left to right are astronauts John L. Phillips, Umberto Guidoni, Chris A. Hadfield, Jeffrey S. Ashby, Kent V. Rominger, cosmonaut Yuri V. Lonchakov, and Scott E. Parazynski. Guidoni is with the European Space Agency and Lonchakov is associated with the Russian Aviation and Space Agency, commonly known as Rosaviakosmos. (Courtesy of NASA.)

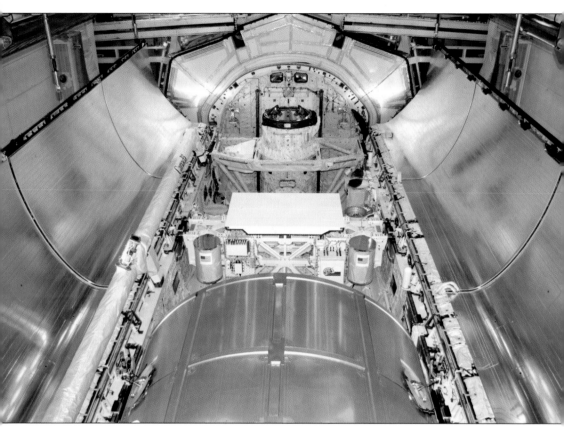

As part of the STS-108 mission, *Endeavour* carried the Expedition Four crew to the International Space Station to replace the Expedition Three crew, who returned to Earth. The payload bay doors on *Endeavour*, seen here, are ready for closure and launch. Seen in the foreground is the Multi-Purpose Logistics Module Raffaello, which carried supplies, equipment, and experiments for the ISS. (Courtesy of NASA.)

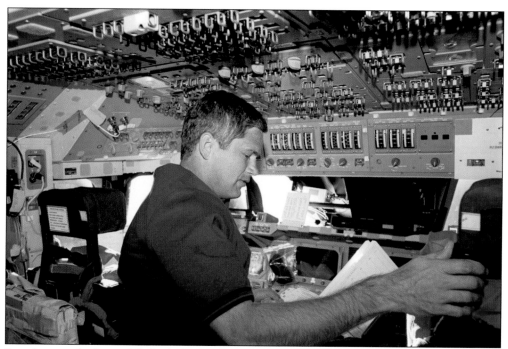

Seen here on the forward flight deck of *Endeavour* is pilot Paul S. Lockhart as he studies a checklist at the commander's station. (Courtesy of NASA.)

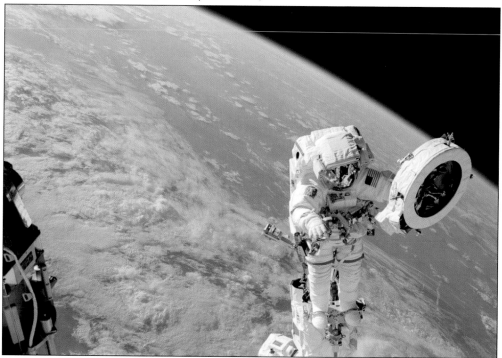

On the International Space Station during STS-111, astronaut Franklin R. Chang-Diaz is working. During his spacewalk, lasting more than seven hours, the Canadarm2 wrist joint was replaced. (Courtesy of NASA.)

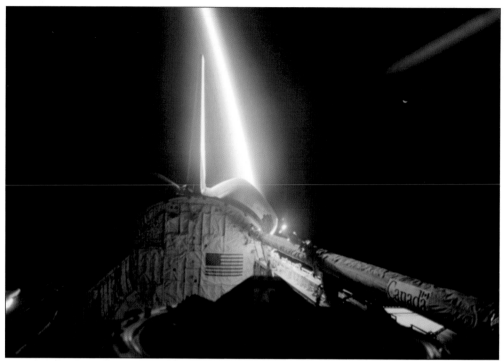

The moon, seen in the upper right, and a thin slice of Earth's horizon running across the photograph, are set against the void of space in this image. Also visible is Space Shuttle *Endeavour*'s payload bay; the RMS is in the lower right. (Courtesy of NASA.)

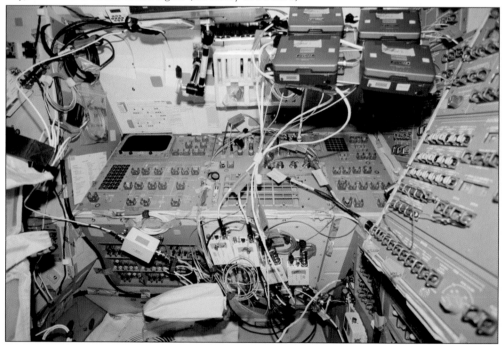

The aft flight deck of *Endeavour* is seen here during the STS-113 mission to the ISS. (Courtesy of NASA.)

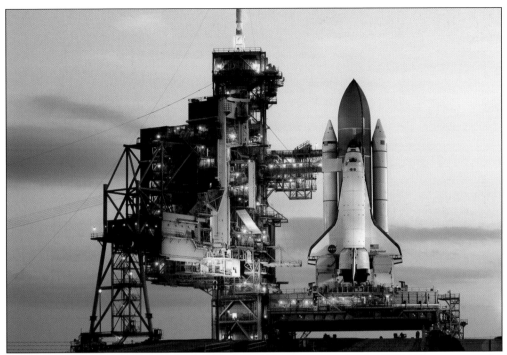

Space Shuttle *Endeavour* is at KSC's Launch Pad 39A, prepping for the STS-118 mission to the ISS. (Courtesy of Larry Tanner, NASA.)

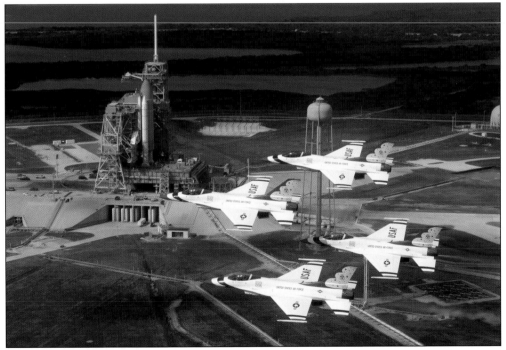

Honoring NASA's 50th anniversary, the USAF Thunderbirds aerobatic display team performs a flyby of KSC's Launch Pad 39A. *Endeavour* is seen awaiting launch for mission STS-123. (Courtesy of T.Sgt. Justin D. Pyle, USAF.)

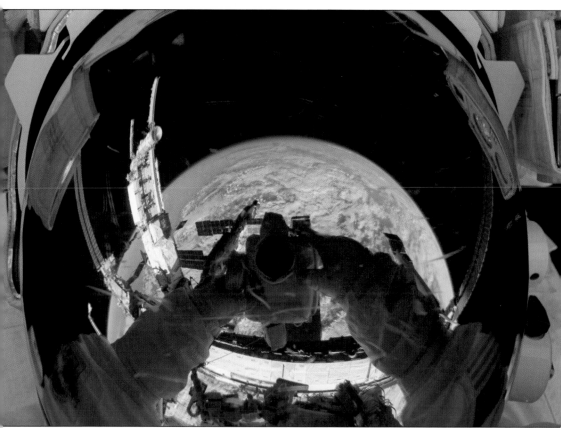

Reflected in the visor of Expedition 15 flight engineer Clay Anderson are assorted components of the station and a bit of Earth. Using a digital camera, Anderson took a photograph of his helmet visor during the mission's third planned EVA session as construction continued on the ISS. (Courtesy of NASA.)

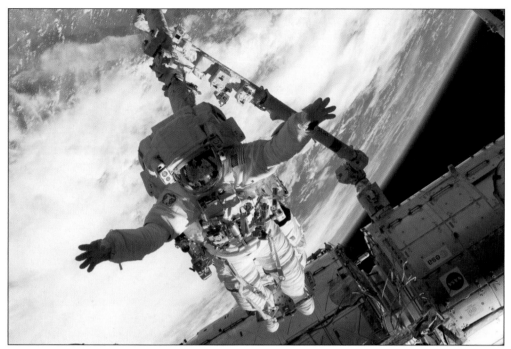

As construction and maintenance continues on the ISS, STS-123 mission specialist Rick Linnehan is attached to a Canadarm2 mobile foot restraint, participating in the mission's first scheduled session of EVA. (Courtesy of NASA.)

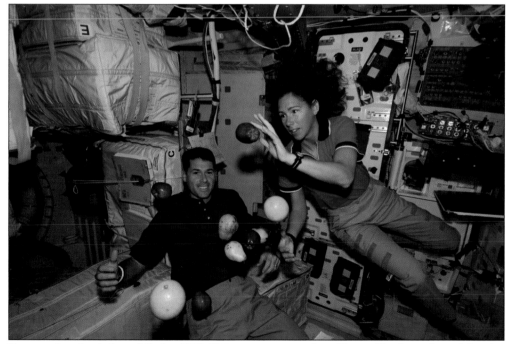

During the third day of flight, STS-126 mission specialists Shane Kimbrough and Sandra Magnus were photographed with fresh fruit floating on the mid-deck of *Endeavour*. (Courtesy of NASA.)

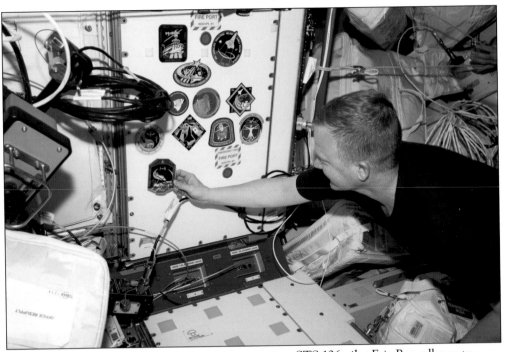

STS-126 pilot Eric Boe adheres to an honored tradition by adding his crew patch to the Unity node, which showcases a growing collection of patches that represent shuttle crews who have worked on the International Space Station. (Courtesy of NASA.)

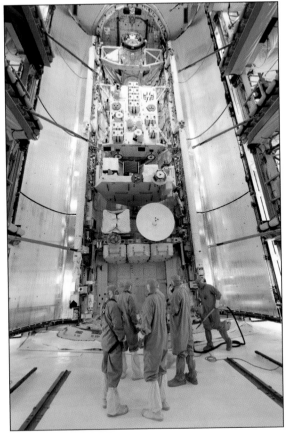

Workers ensure smooth closure of the shuttle payload bay doors on KCS's Launch Pad 39A. Their sanitary outfits ensure that no contamination makes its way into the payload bay. (Courtesy of Paul E. Alers, NASA.)

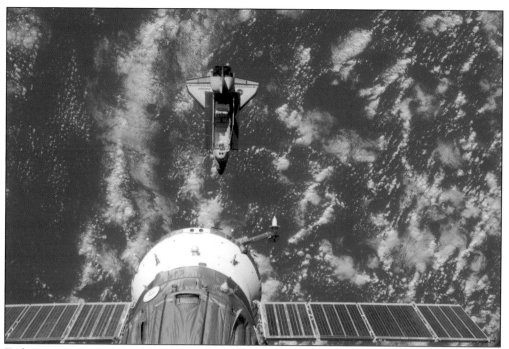

Endeavour is pictured shortly after the shuttle and station began their post-undocking separation during the STS-127 mission. (Courtesy of NASA.)

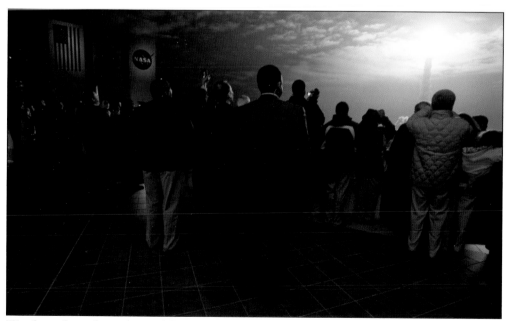

Watching from the terrace of Operations Support Building II, guests observe as *Endeavour* is launched from KSC's Launch Pad 39A, destined for the ISS. Mission STS-130 delivered the Italian-built Tranquility node and a seven-window cupola, which is used as a control room for robotics. (Courtesy of Paul E. Alers, NASA.)

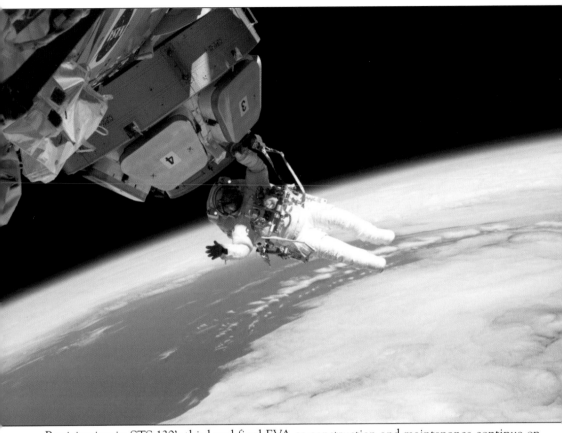

Participating in STS-130's third and final EVA as construction and maintenance continue on the ISS is mission specialist Nicholas Patrick. During the spacewalk, which lasted five hours and 48 minutes, Patrick and mission specialist Robert Behnken completed all tasks, including removing insulation blankets and launch restraint bolts from each of the cupola's seven windows. (Courtesy of NASA.)

Four

A FINAL SPACE FLIGHT

On May 7, 2011, *Endeavour* celebrated the 19th anniversary of her first launch and the 20th anniversary of her delivery to the KSC. *Endeavour's* final flight was a long and awe-inspiring mission as she delivered the final round of external spare parts for the ISS and the premiere scientific experiment: the Alpha Magnetic Spectrometer 2, which observe the universe and seeks evidence of and information on dark matter, dark energy, and antimatter. (Courtesy of NASA.)

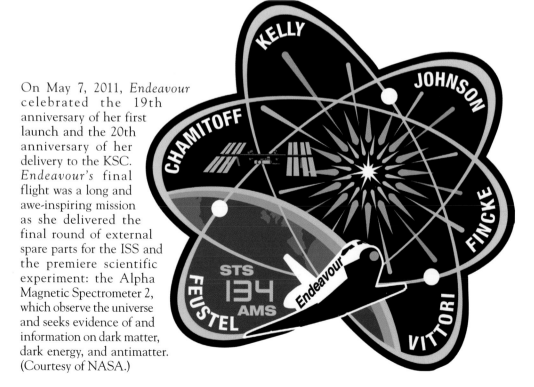

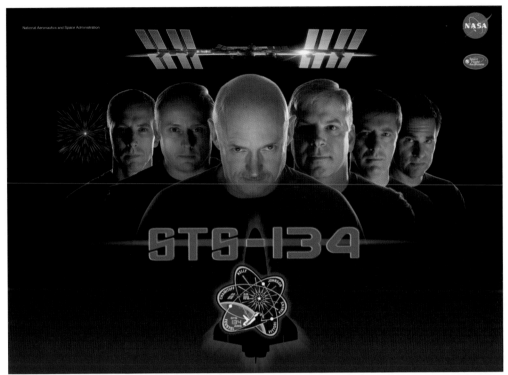

The official STS-134 NASA Space Flight Awareness poster showcases, from left to right, astronauts Andrew Feustel, Greg Chamitoff, Mark Kelly, Gregory H. Johnson, Michael Fincke, and Roberto Vittori. (Courtesy of Logan Goodson, NASA.)

This photograph was taken at KSC in Cape Canaveral, Florida, on April 28, 2011, a stormy day. *Endeavour* is sitting on launch pad 39A before the rollback of the Rotating Service Structure (RSS). The STS-134 crew will deliver the Alpha Magnetic Spectrometer and spare parts during the 14-day mission. (Courtesy of Bill Ingalls, NASA.)

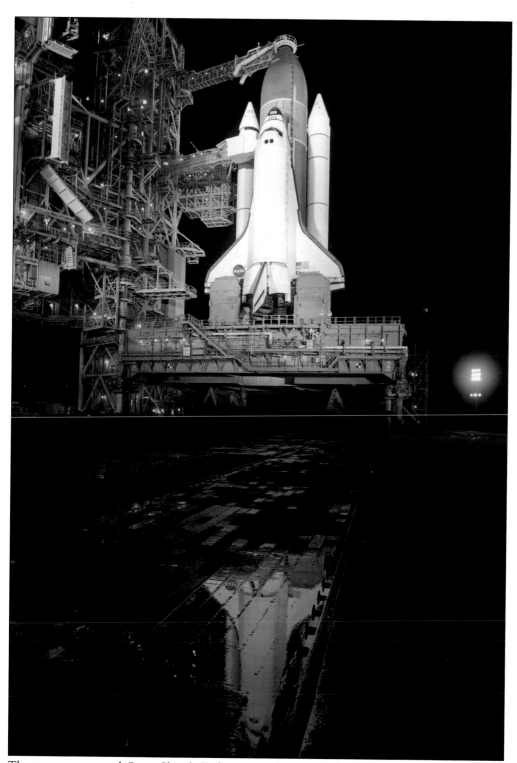

The storm now passed, Space Shuttle *Endeavour* can be seen on launch pad 39A after the rollback of the RSS. (Courtesy of Bill Ingalls, NASA.)

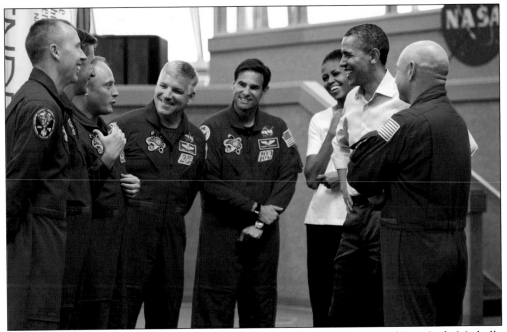

After the launch was cancelled on April 29, 2011, Pres. Barack Obama and First Lady Michelle Obama met with *Endeavour's* STS-134 crew at KSC. The crew consisted of, from left to right, Andrew Feustel, ESA's Roberto Vittori, Michael Fincke, Greg H. Johnson, Greg Chamitoff, and commander Mark Kelly. (Courtesy of Bill Ingalls, NASA.)

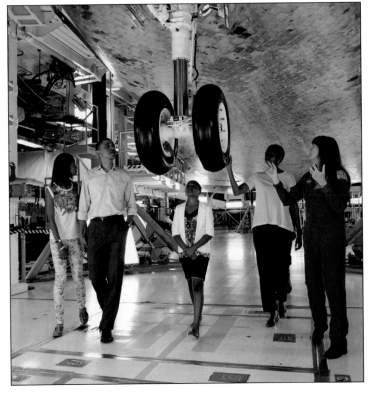

President Obama, First Lady Michelle Obama, and daughters Malia and Sasha join astronaut Janet Kavandi for a walk under the landing gear of Space Shuttle *Atlantis* during a visit to KSC on April 29, 2011. (Courtesy of Bill Ingalls, NASA.)

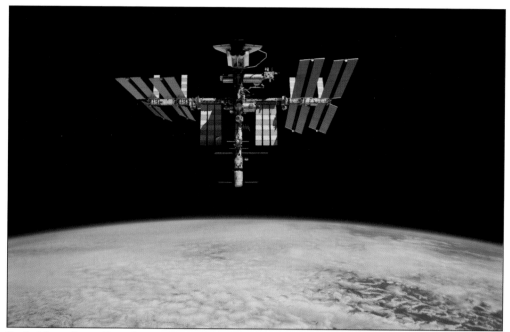

Paolo Nespoli, an Expedition 27 crew member, took this photograph from the Soyuz TMA-20 after its undocking on May 23, 2011; it shows the ISS and the docked *Endeavour* as it flew at an altitude of approximately 220 miles. This image was among the first of a shuttle docked to the ISS from the perspective of a Russian Soyuz spacecraft. (Courtesy of NASA.)

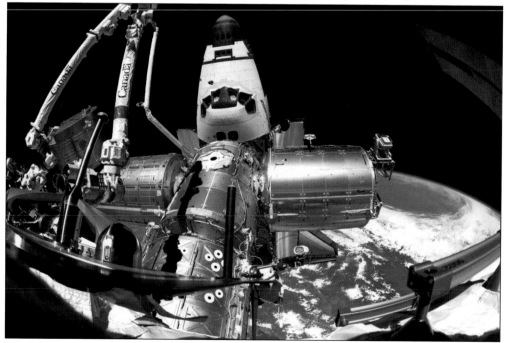

This photograph, taken with a fish-eye lens during STS-134's fourth EVA, shows the ISS and the docked shuttle. Earth's glow against the darkness of space provides a remarkable setting. (Courtesy of NASA.)

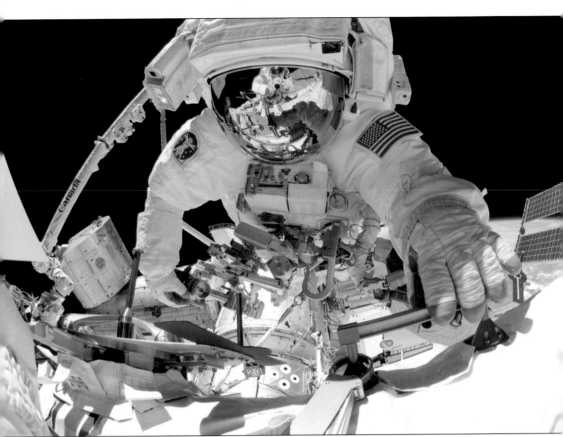

Construction and maintenance continued on the ISS during STS-134's fourth EVA. The mission delivered the Alpha Magnetic Spectrometer to the ISS. Mission specialists Greg Chamitoff (pictured) and Michael Fincke (visible in the reflection on Chamitoff's helmet visor), had prepared for their seven-hour, 24-minute spacewalk by spending the previous night in the Quest airlock with reduced pressure to avoid decompression sickness during the spacewalk. (Courtesy of NASA.)

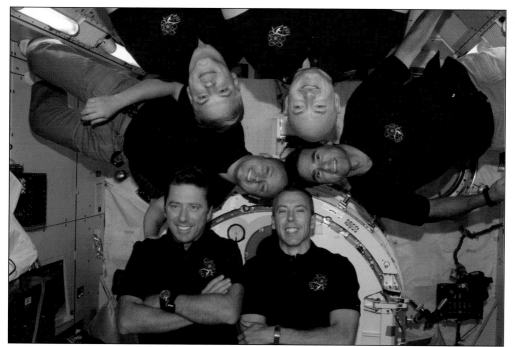

Posing in the Japan Aerospace Exploration Agency's Kibo Lab on the ISS is the six-member crew for STS-134, *Endeavour's* final mission. Clockwise from top right is commander Scott Kelly, NASA astronauts Greg Chamitoff and Andrew Feustel, ESA astronaut Roberto Vittori, and NASA astronaut Michael Fincke, all mission specialists, and NASA astronaut and pilot Greg H. Johnson. (Courtesy of NASA.)

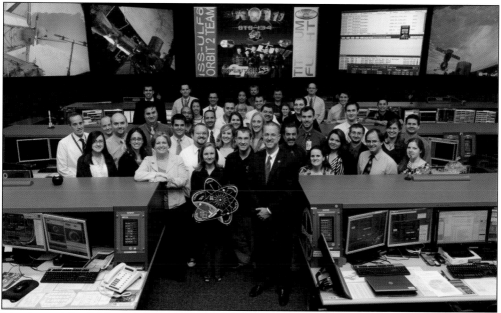

Members of the STS-134/ULF-6 ISS Orbit 2 flight control team gather for a photograph in the space station flight control room in the Mission Control Center at NASA's Johnson Space Center. Flight director Derek Hassman stands front row, center. (Courtesy of NASA.)

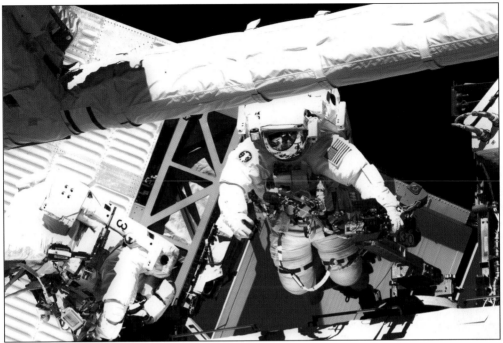

Chamitoff and Fincke completed all of STS-134's primary objectives during the 7-hour, 24-minute spacewalk, including stowing the 50-foot-long boom and adding a power and data grapple fixture to make it the Enhanced ISS Boom Assembly; this addition was used to extend the reach of the ISS's robotic arm. (Courtesy of NASA.)

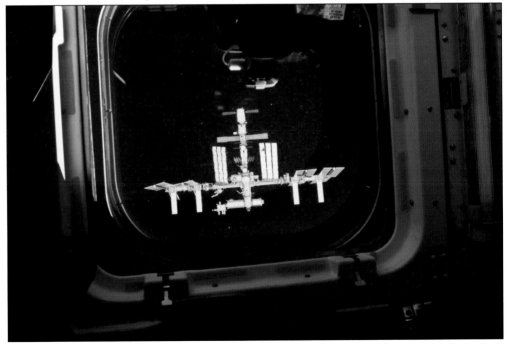

A STS-134 crew member took this photograph of the ISS from one of *Endeavour's* aft flight deck windows during rendezvous and docking operations. (Courtesy of NASA.)

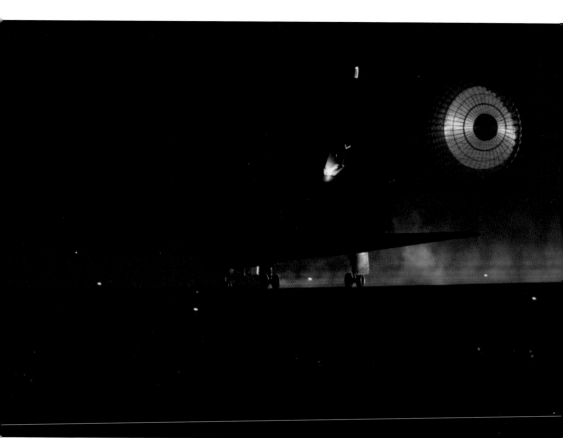

STS-134 was the 25th and final flight for *Endeavour*; the ship spent 299 days in space, orbited Earth 4,671 times, and traveled 122,883,151 miles. As it rolls to a stop for the last time, *Endeavour's* drag chute is illuminated by Xenon lights on KSC's Shuttle Landing Facility's Runway 15. (Courtesy of NASA.)

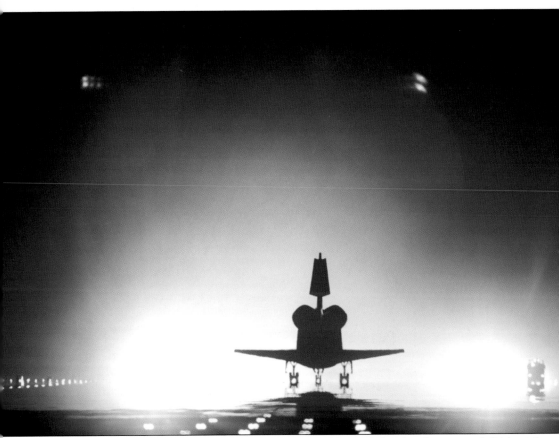

Endeavour's last landing took place on June 1, 2011. This was the shuttle program's 24th night landing. Onboard were NASA astronauts commander Mark Kelly, pilot Greg H. Johnson, and mission specialists Michael Fincke, Andrew Feustel, Greg Chamitoff, and Roberto Vittori. (Courtesy of NASA.)

Five

DECOMMISSIONING

At 9:58 a.m. on May 11, 2012, almost a year from her final launch on May 16, 2011, technicians finally unplugged *Endeavour*, NASA's last powered orbiter, for the last time. Terminating all power to the flight deck, technicians began preparations inside Orbiter Processing Facility-2 (OPF-2) for *Endeavour*'s departure from KSC to her final resting place in Los Angeles's California Science Center later in the year. (Courtesy of NASA.)

STANDARD FORM 122 JUNE 1974 GENERAL SERVICES ADMINISTRATION FPMR (41 CFR) 101-32.306 FPMR (41 CFR) 101-43.315	TRANSFER ORDER EXCESS PERSONAL PROPERTY	1. ORDER NO. 11C0198
		2. DATE

3. TO: General Services Administration*

4. ORDERING AGENCY *(Full name and address)**
CALIFORNIA SCIENCE CENTER FOUNDATION
700 EXPOSITION PARK DRIVE
LOS ANGELES, CA 90037

5. HOLDING AGENCY *(Name and address)**
NASA KENNEDY SPACE CENTER DISPOSAL OFFICE
BLDG. M6-1723, SR 3-PAULETTA K. MCGINNIS, NASA TA-A5A
KENNEDY SPACE CENTER, FL 32899

6. SHIP TO *(Consignee and destination)**
California Science Center Foundation POC Jeffrey N. Rudolph
700 Exposition Park Drive
LOS ANGELES, CA 90037

7. LOCATION OF PROPERTY
NASA KENNEDY SPACE CENTER
BLDG. K6-894/HB2
KENNEDY SPACE CENTER, FL 32899

8. SHIPPING INSTRUCTIONS
NASA shall return the Bailed Property to the Recipient at Los Angeles International Airport (the "Airfield Site") upon the completion of the Purpose set forth herein the RSAA.

9. ORDERING AGENCY APPROVAL
a. SIGNATURE
b. DATE 10-7-11
c. TITLE JEFFREY N. RUDOLPH, PRESIDENT, CSC FOUNDTION

10. APPROPRIATION SYMBOL AND TITLE

11. ALLOTMENT

12. GOVERNMENT B/L NO.

13. PROPERTY ORDERED

GSA AND HOLDING AGENCY NOS. (a)	ITEM NO. (b)	DESCRIPTION (Include noun name FSC Group and Class, Condition code and, if available, National Stock Number) (c)	UNIT (d)	QUANTITY (e)	ACQUISITION COST UNIT (f)	TOTAL (g)
	1.	ORBITER, SHUTTLE ENDEAVOUR, OV-105 consisting of disposal case numbers: (1) 80420012720021S (ECN 1023442): (2) 80420012720022S (ECN 1023443); and (3) 80420012720023S (ECN 1993342) MFG: ROCKWELL INT'L SPACE TRANSPORTATION MODEL: MV0070A/SERIAL NUMBER: OV-105 CONDITION CODE: FOR DISPLAY ONLY MFG YR: 1991- FSC 1810	EA	1	$1	980,674,785.00
		Total of Property Ordered			$1	980,674,785.00

14. GSA APPROVAL	a. SIGNATURE Pauletta K. McGinnis	b. TITLE Pauletta K. McGinnis NASA/KSC Property Disposal Officer	c. DATE
FOR GSA USE ONLY	AGENCY AND LOCATION AGENCY STATE	FSC CONDITION SOURCE CODE	

**Include ZIP Code*

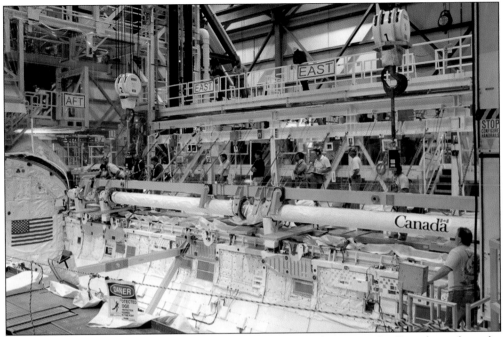

KSC workers are seen disconnecting the shuttle's RMS, also known as the Canadarm, from the payload bay on June 15, 2011. (Courtesy of Tim Jacobs, NASA.)

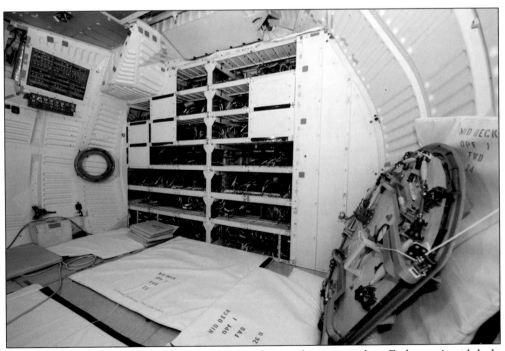

A removed hatch door and protective padding sit along with open panels in *Endeavour's* mid-deck, exposing shuttle electrical systems during their decommissioning. (Courtesy of NASA.)

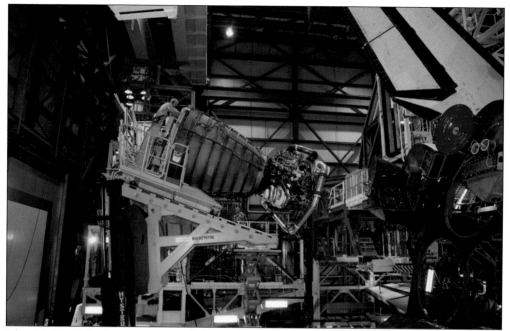

The third and final main engine of the *Endeavour* is being removed and will be moved to the engine shop, where it will be recycled for use in other future spacecraft. The engines will be replaced with high quality replicas prior to the move to the California Science Center. (Courtesy of NASA.)

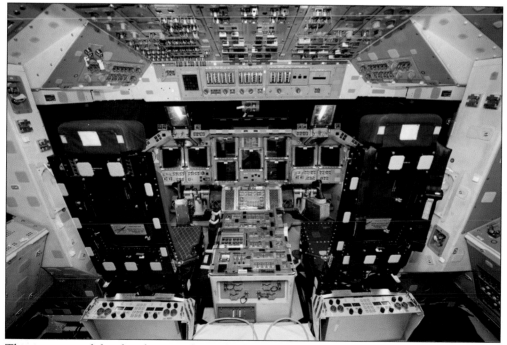

This is a view of the shuttle controls inside the spacecraft's flight deck. Workers disconnected and dismantled components on *Endeavour* in Orbiter Processing Facility-1 (OPF-1) at Kennedy Space Center in June 2011. (Courtesy of Kim Shiflett, NASA.)

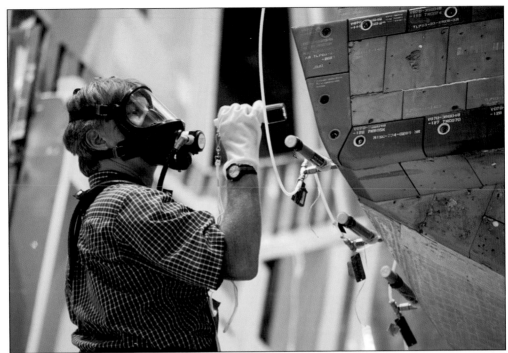

The left-hand orbital maneuvering system pod is being inspected by a technician at OPF-1. This is one of the many preparations that took place before the shuttle could be moved to the science center. (Courtesy of Frank Michaux, NASA.)

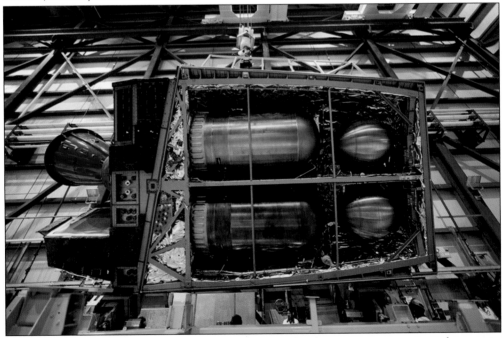

The underside of *Endeavour*'s now-removed left-hand orbital maneuvering system pod is seen in this July 28, 2011, image as a crane lowers the component onto a transporter. (Courtesy of Frank Michaux, NASA.)

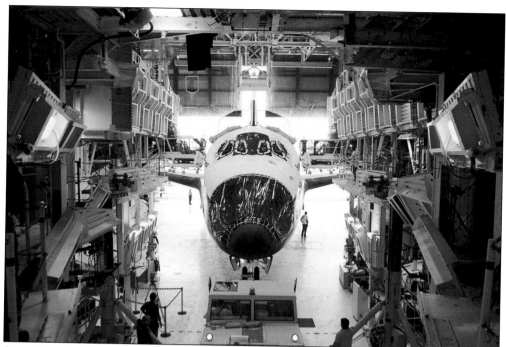

Space Shuttle *Endeavour* moves slowly toward OPF-1's open door on August 11, 2011, at NASA's KSC. (Courtesy of Jim Grossmann, NASA.)

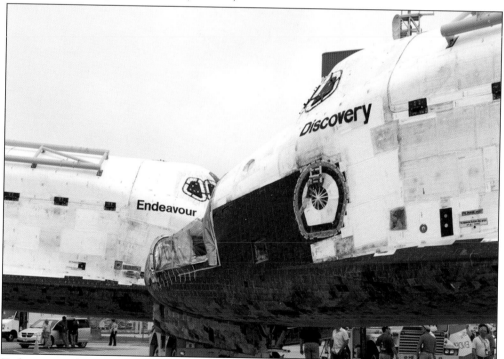

Endeavour and *Discovery* part ways outside OPF-3 on August 11, 2011, where they stopped for a nose-to-nose photograph. *Discovery* was stored temporarily in the Vehicle Assembly Building while *Endeavour* was being decommissioned in OPF-1. (Courtesy of Frankie Martin, NASA.)

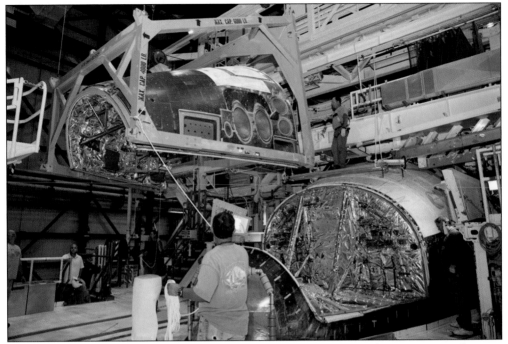

In this image, taken on February 8, 2012, a crane is moving the forward reaction control system (FRCS) so that it can be installed in *Endeavour*. The FRCS, which helped to maneuver *Endeavour* while she was in orbit, was scrubbed of its toxic propellants at the White Sands Test Facility in New Mexico. (Courtesy of Dimitri Gerondidakis, NASA.)

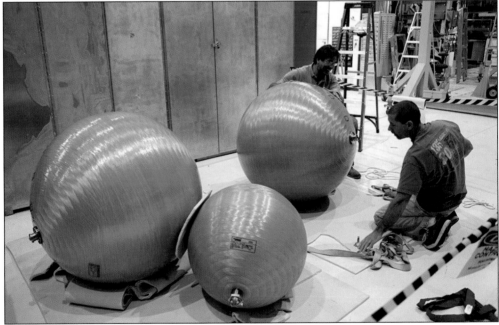

On March 21, 2012, *Endeavour's* main propulsion system tanks were secured by United Space Alliance technicians at KSC. The tanks, which had been located on the shuttle's mid-body, will be retained for possible future use. (Courtesy of Dimitri Gerondidakis, NASA.)

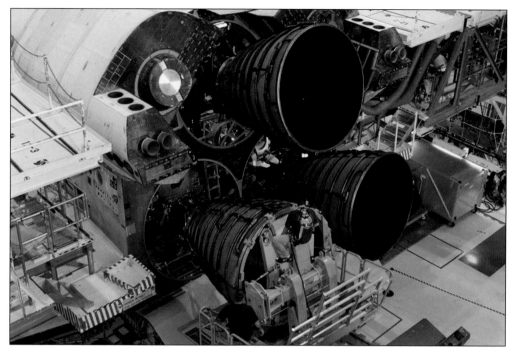

A Hyster forklift, controlled by a United Space Alliance technician, attempts to place the replica Shuttle Main Engine Two in *Endeavour* as other technicians in the aft area monitor the progress. This took place inside OPF-2 at NASA's KSC on July 13, 2012. (Courtesy of David Lee, NASA.)

Bobby Wright, a United Space Alliance senior aerospace technician, readies two launch and entry seats to be moved from the shuttle's mid-deck to the flight deck in preparation for *Endeavour's* journey to California. (Courtesy of Jim Grossmann, NASA.)

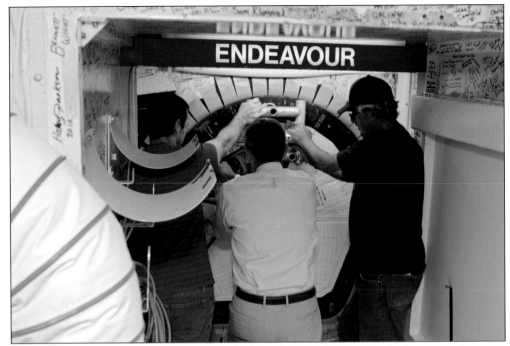

KSC director Bob Cabana, center, is seen locking the shuttle door for the last time. Assisting him are United Space Alliance technicians Gary Hamilton, left, and Joe Walsh. (Courtesy of Jim Grossmann, NASA.)

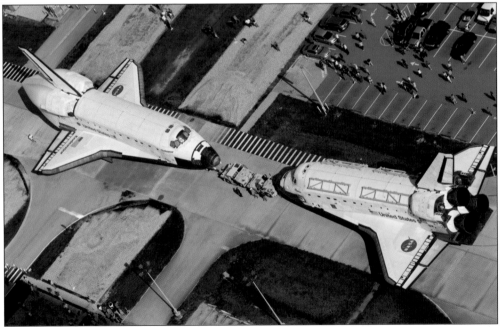

As this is the last time the two shuttles will be together, *Endeavour*, left, and *Atlantis* are parked nose-to-nose to take advantage of one last photographic opportunity. The shuttles are trading spaces, with *Atlantis* moving to OPF-2 and *Endeavour* headed to the Vehicle Assembly Building in preparation for departure to California. (Courtesy of Frankie Martin, NASA.)

Six

MISSION 26

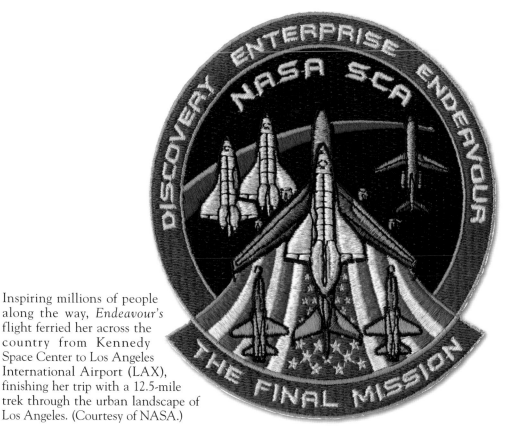

Inspiring millions of people along the way, *Endeavour's* flight ferried her across the country from Kennedy Space Center to Los Angeles International Airport (LAX), finishing her trip with a 12.5-mile trek through the urban landscape of Los Angeles. (Courtesy of NASA.)

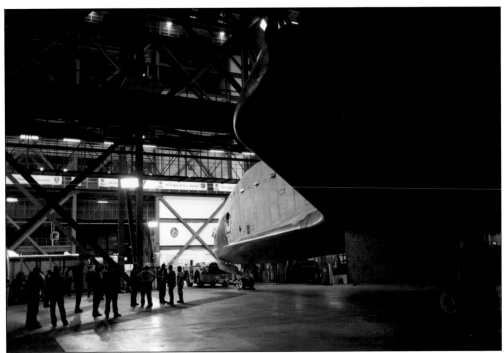

KSC workers get instructions prior to moving *Endeavour* out of the Vehicle Assembly Building and to the Mate-Demate Device (MDD), which will lift the shuttle onto the Shuttle Carrier Aircraft (SCA). (Author's collection.)

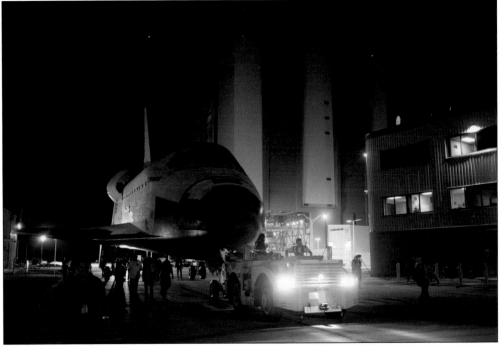

Workers and media tail *Endeavour* as she makes her way to SCA in preparation for her flight to California. (Author's collection.)

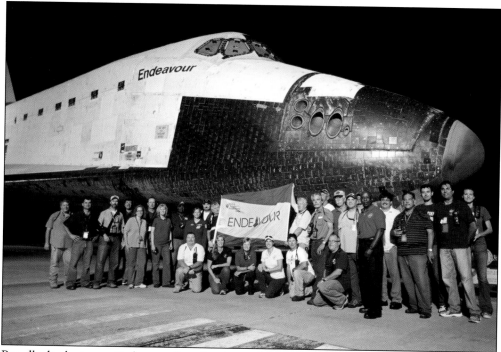

Proudly displaying an *Endeavour* flag, shuttle employees gather in front of the shuttle for the last time. (Author's collection.)

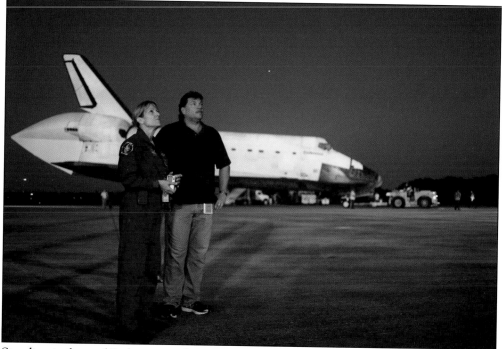

Standing in front of *Endeavour* as she is towed to the MDD are Capt. Kay Hire, astronaut, and Bartholomew Pannullo, NASA's transition & retirement vehicle manager. (Author's collection.)

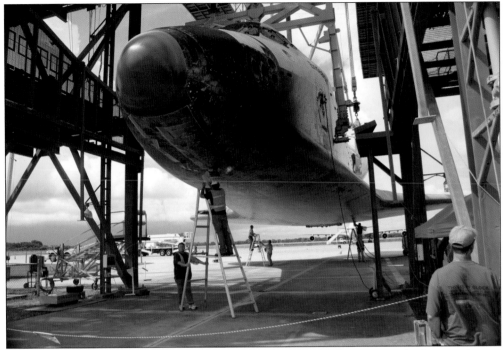

Endeavour's landing gear is retracted by shuttle technicians as they prepare for her attachment to the SCA. (Author's collection.)

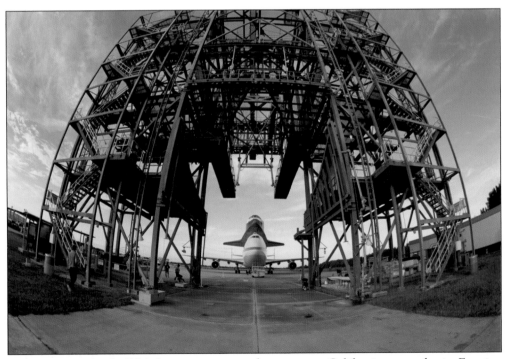

Endeavour sits atop the SCA, her journey across the country to California soon to begin. Framing the pair is the MDD. (Author's collection.)

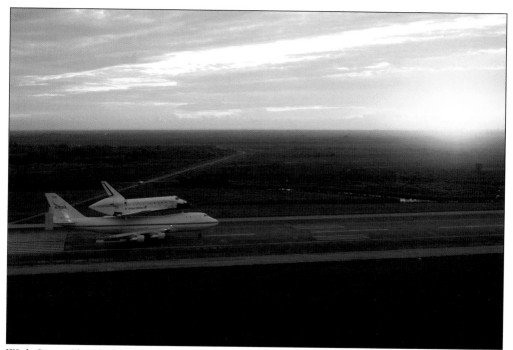

With Space Shuttle *Endeavour* securely fastened on top, NASA's SCA takes off down the runway at KSC at 7:22 a.m. on September 19, 2012. This takeoff marked the beginning of the final ferry flight scheduled in the Space Shuttle era. (Courtesy of Kim Shiflett, NASA.)

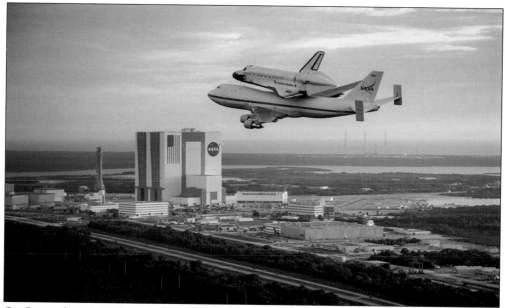

On September 19, 2012, the SCA, carrying the Space Shuttle *Endeavour*, flew over the Vehicle Assembly Building at KSC one last time before heading to California. (Courtesy of Robert Markowitz, NASA.)

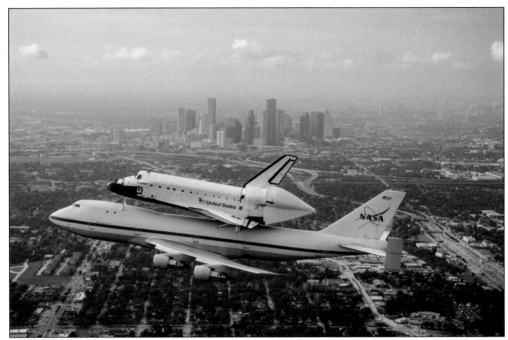

Endeavour is flown over Houston, Texas, on September 19, 2012, before landing at Ellington Field Joint Reserve Base, the first of three stops before the shuttle's ultimate arrival in Los Angeles. (Courtesy of Sheri Locke, NASA.)

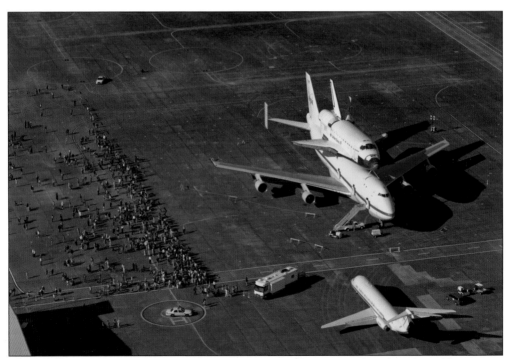

This image, taken from a Coast Guard helicopter, shows the crowd gathered for the public viewing of *Endeavour* at Ellington Field on September 19, 2012. (Courtesy of James Blair, NASA.)

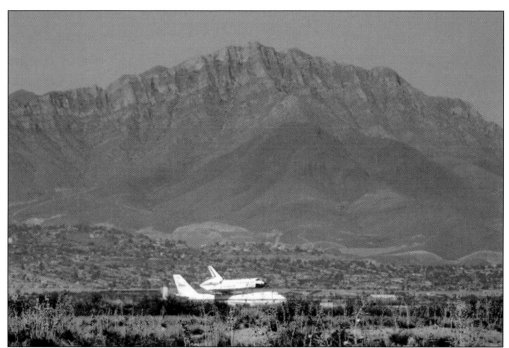

The SCA takes off from its second stop, which took place on September 20, 2012, at the Biggs Army Airfield in Fort Bliss, Texas. Having refueled, the SCA was now ready to make its way to Edwards AFB. (Courtesy of US Army Sgt. Erik Thurman, 15th Sustainment Brigade Public Affairs.)

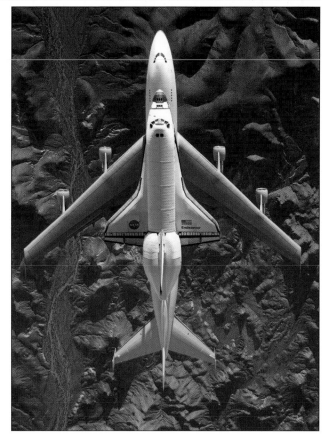

Endeavour is photographed from above as the SCA flies her over the Mojave Desert. (Courtesy of Carla Thomas, NASA.)

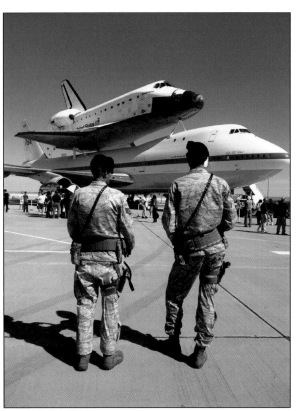

Two Edwards AFB airmen walk around *Endeavour* on the base's runway to ensure its safety and security. (Courtesy of Jessica Jurges.)

On September 21, 2012, at 8:17 a.m., the SCA took off with *Endeavour* from Edwards Air Force Base, beginning a 4.5-hour flyover of Northern California and the Los Angeles basin. (Courtesy of Jet Fabara, USAF.)

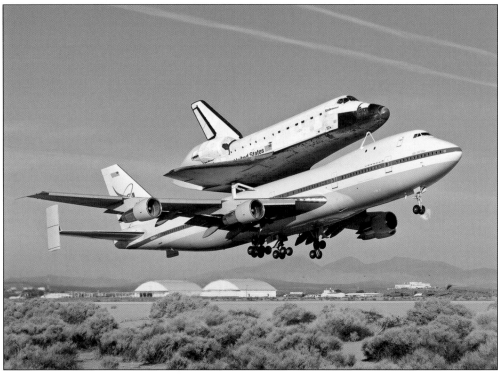

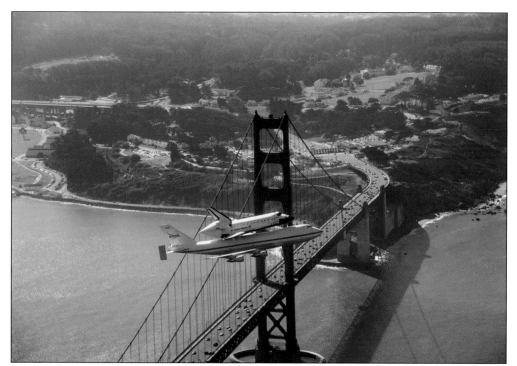

During the final portion of the shuttle's tour of California, *Endeavour* and her carrier flew over the Golden Gate Bridge. (Courtesy of Carla Thomas, NASA.)

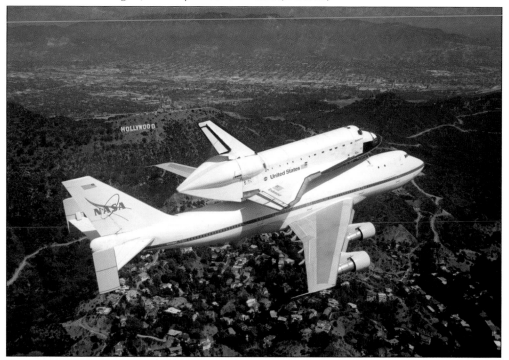

During their final ferry mission, the SCA-*Endeavour* team flew over many Los Angeles landmarks, including the Hollywood sign. (Courtesy of Jim Ross, NASA.)

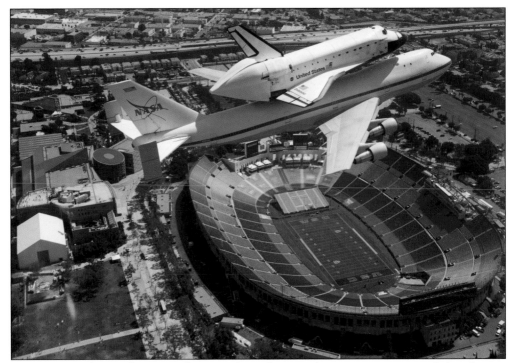

The shuttle and SCA fly over *Endeavour's* future home—the science center—and the adjacent Los Angeles Memorial Coliseum. *Endeavour* is now on exhibit in the Samuel Oschin Pavilion, the white building at left. (Courtesy of Jim Ross, NASA.)

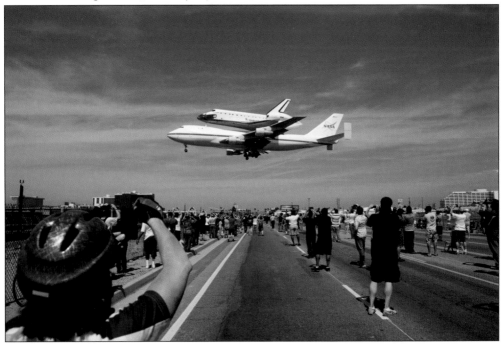

Endeavour's landing at LAX on September 21, 2012, prompted spectators to take photographs and watch in awe. (Courtesy of Matt Hedges, NASA.)

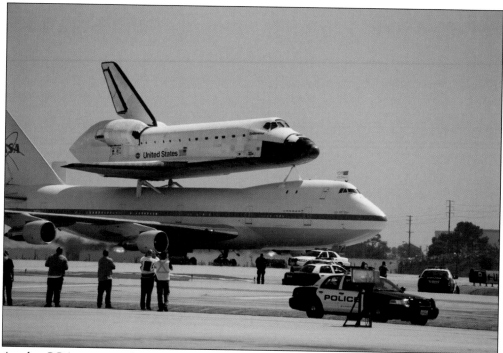

As the SCA taxis in from the runway at LAX, Jim Johnston of the Federal Aviation Administration, a member of the SCA flight team, waves an American flag from the top hatch. (Author's collection.)

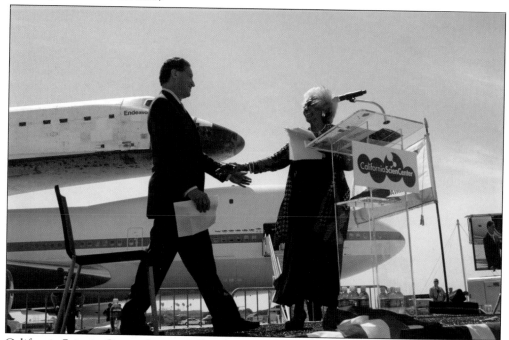

California Science Center director Jeffrey Rudolph and Nichelle Nichols, who played Lieutenant Uhura on television's *Star Trek*, are seen on stage as part of *Endeavour's* welcoming ceremonies. (Author's collection.)

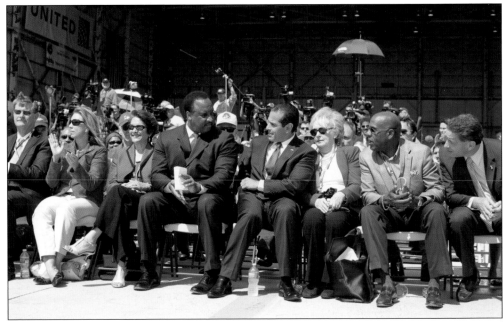

Seen here at *Endeavour*'s welcoming ceremony are United Airlines director of technical operations at LAX Don Wright, NASA deputy administrator Lori Garver, California Consumer Services Agency secretary Anna Caballero, Inglewood mayor James T. Butts, Los Angeles mayor Antonio Villaraigosa, Mr. and Mrs. Samuel Oschin Family Foundation chair Lynda Oschin, California assemblyman Steve Bradford, and California Science Center president and CEO Jeffrey N. Rudolph. (Author's collection.)

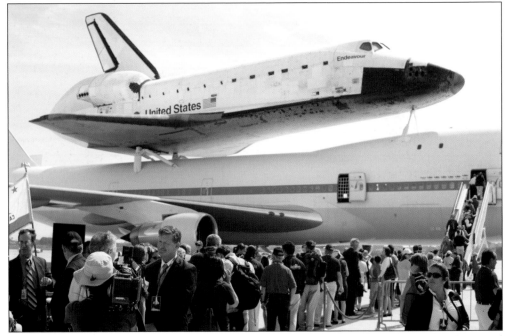

Guests were allowed to enter the SCA for a brief tour before the shuttle was unloaded and prepped for her journey through Los Angeles. (Author's collection.)

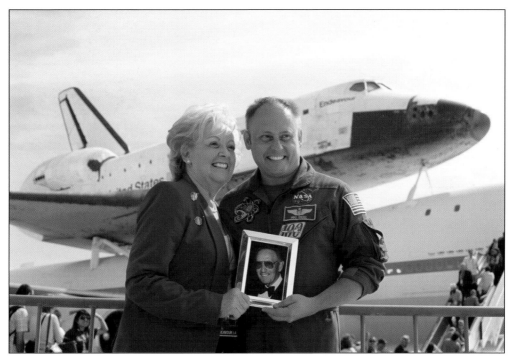

Lynda Oschin is seen posing with astronaut Mike Fincke in front of the *Endeavour* at the end of the welcoming ceremony. Oschin is holding a photograph of her late husband Samuel Oschin that was flown on the SCA from Florida. (Author's collection.)

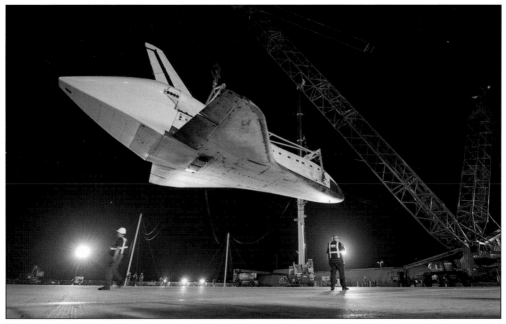

Endeavour is pictured being taken off the SCA on September 21, 2012, at LAX. (Courtesy of Bill Ingalls, NASA.)

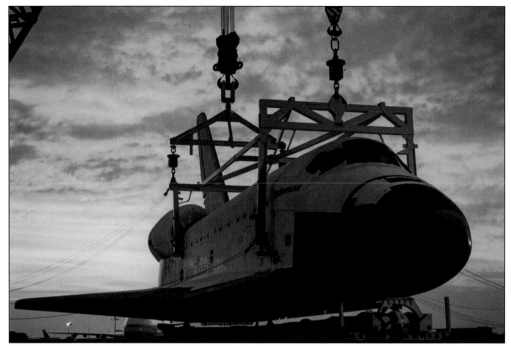

Endeavour is shown being attached to the Over Land Transporter (the yellow machinery seen below the shuttle) on top of the four Sarens vehicles that will move the shuttle through the streets of Los Angeles. (Courtesy of Bill Ingalls, NASA.)

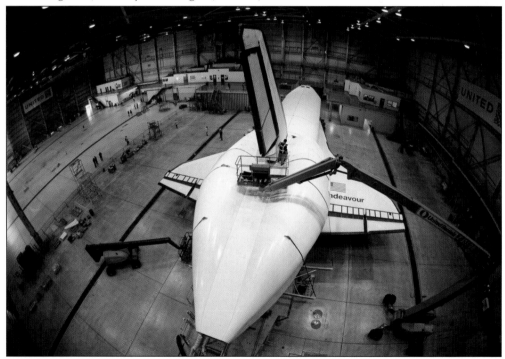

The United Airlines hangar houses *Endeavour* as preparations commence for her 12.5-mile journey through Los Angeles. (Author's collection.)

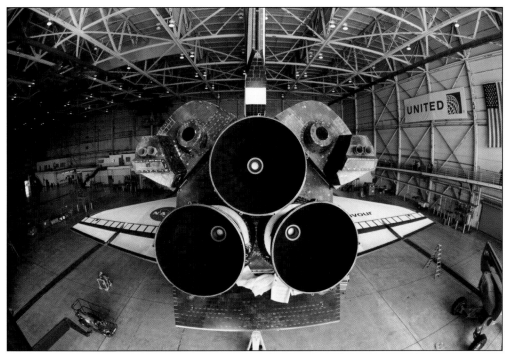

Inside the United Airlines hanger at LAX, the shuttle is prepared for its move to the science center. The tail cone will be removed, water pumped out, and final touches made over the following weeks. (Author's collection.)

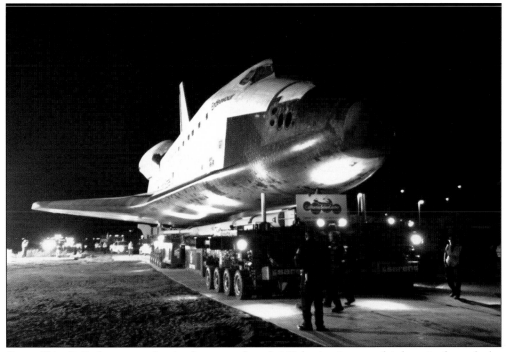

Space Shuttle *Endeavour* makes its departure from LAX, beginning a multi-day trip through the streets of Los Angeles. (Courtesy of Mark August.)

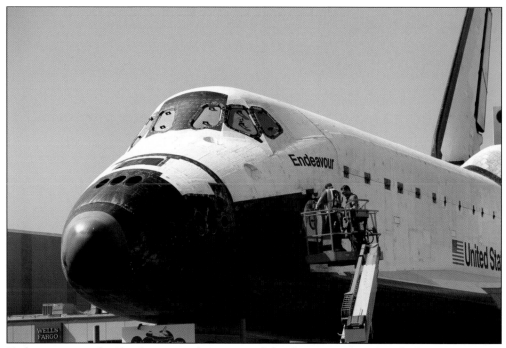

Endeavour stops for the first reconfiguration of the Sarens transporters before continuing. Christopher Gabriel and Eric Schulte are using a scissor lift to replace data cards in the video cameras mounted on the side of the shuttle hatch. (Author's collection.)

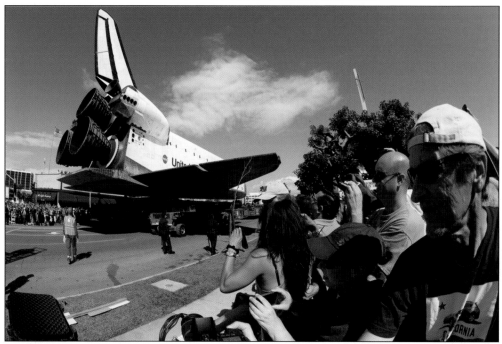

Thousands of people could be seen at any given point along *Endeavour's* route to the California Science Center. Over a million people came out during *Endeavour's* three-day trip through the city. (Author's collection.)

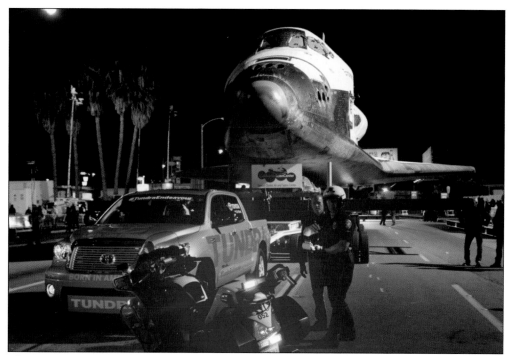

This Toyota Tundra, towing the *Endeavour*, is stopped by a Los Angeles Police Department officer for a gag photo of the pair getting a speeding ticket. (Author's collection.)

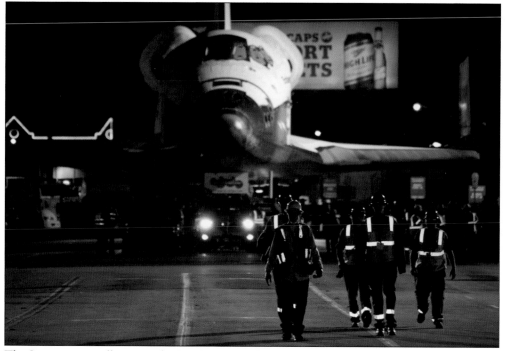

The Sarens team walks across the I-405 overpass, the *Endeavour* being towed by the Toyota Tundra behind them. This was done for fear that the total weight of the shuttle and Sarens units could cause a collapse of the bridge. (Author's collection.)

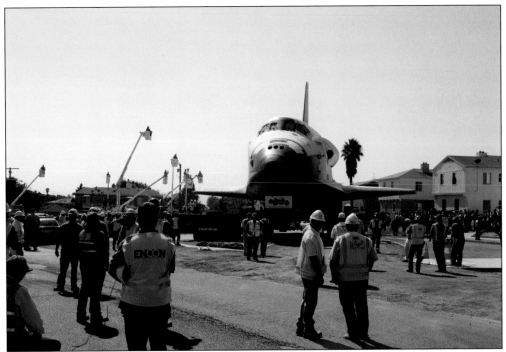

At the top of its highest climb, the *Endeavour* was met by over a dozen cherry pickers and hundreds of people as it prepared for its longest straightaway. (Author's collection.)

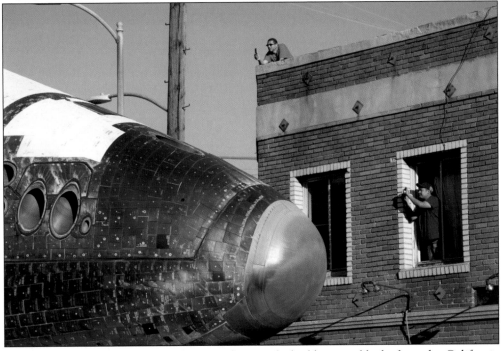

The nose of *Endeavour* passes by the second story of a building just blocks from the California Science Center. All along the route, people could be found climbing on cars, trucks, buildings, and even billboards to get a better view of the shuttle as she passed. (Author's collection.)

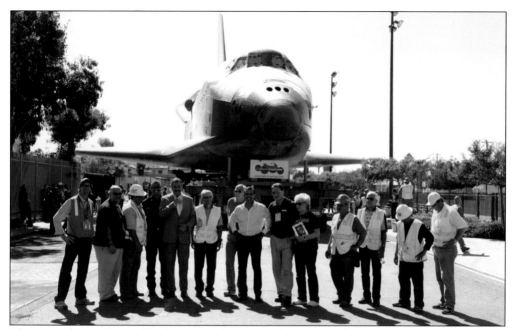

Those standing in front of *Endeavour* as she crosses the finishing line include Los Angeles mayor Antonio Villaraigosa; California Science Center president Jeffrey Rudolph; Lynda Oschin, widow of Samuel Oschin, after whom *Endeavour's* new home is named; project director Marty Fabric; Los Angeles Police Commission president Steve Soboroff; and Los Angeles fire chief Brian Cummings. (Author's collection.)

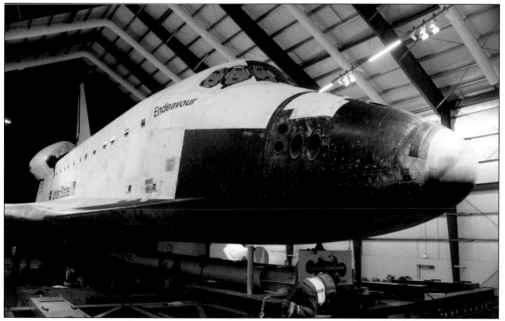

October 30, 2012, marked the launch of *Endeavour's* newest and longest mission: to inspire a new generation of explorers, scientists, and engineers. According to the California Science Center, as many as 2.5 million visitors came to see the Space Shuttle *Endeavour's* display in just its first year. (Author's collection.)

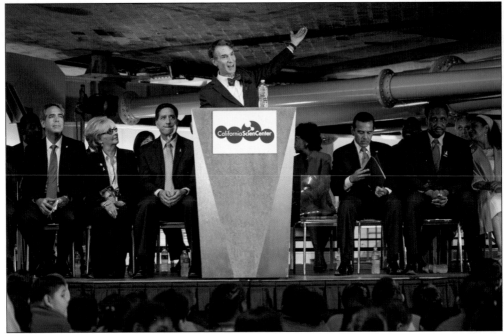

The grand opening ceremony for the center's Samuel Oschin Space Shuttle *Endeavour* Display Pavilion took place on Tuesday, October 30, 2012. Planetary Society CEO Bill Nye "the Science Guy" was the emcee and spoke from a podium underneath *Endeavour* during the event. (Author's collection.)

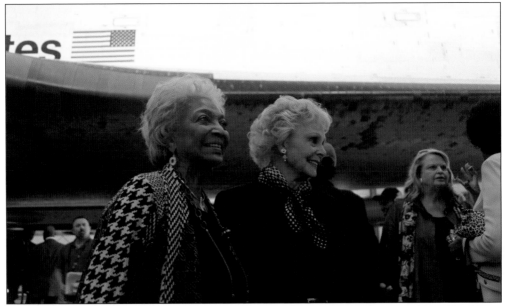

Veteran space aficionados and actresses Nichelle Nichols, *Star Trek*'s Uhura, and June Lockhart, *Lost in Space*'s Principal Cartwright, were on hand to welcome *Endeavour*. Nichols, interested in space travel, flew aboard NASA's C-14 Astronomy Observatory and, after the end of *Star Trek*, volunteered much of her time to NASA in order to recruit minority and female personnel for the space agency. (Author's collection.)

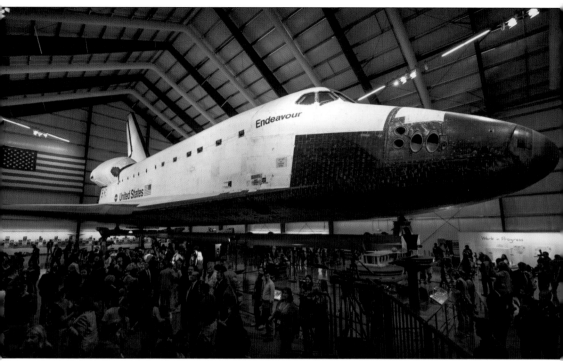

Guests are chatting and standing around *Endeavour* during the grand opening ceremony for the California Science Center's Samuel Oschin Space Shuttle *Endeavour* Display Pavilion. (Courtesy of Bill Ingalls, NASA.)

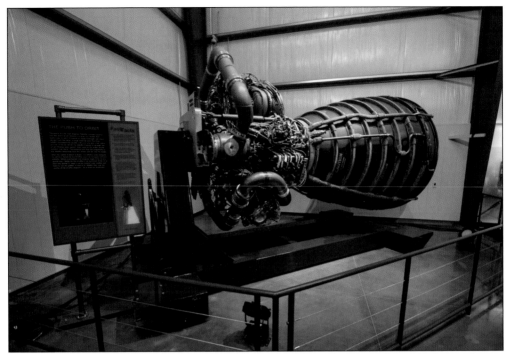

On display at the California Science Center with the Space Shuttle *Endeavour* is an authentic Space Shuttle Main Engine. *Endeavour* has replicas installed. (Author's collection.)

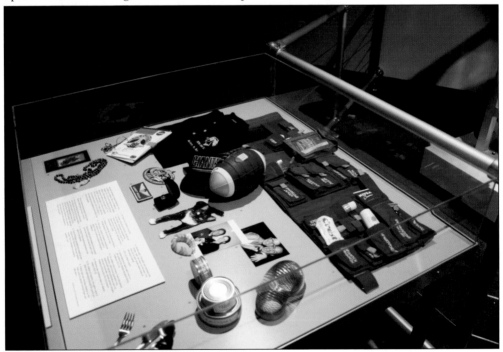

The display seen here includes personal photographs, space food samples, and a hygiene kit. These all belong to astronaut Garrett Reisman, who loaned the California Science Center many of his personal mementos from his 2008 flight to the ISS on *Endeavour*. (Author's collection.)

Seven

THE SHUTTLE PROGRAM

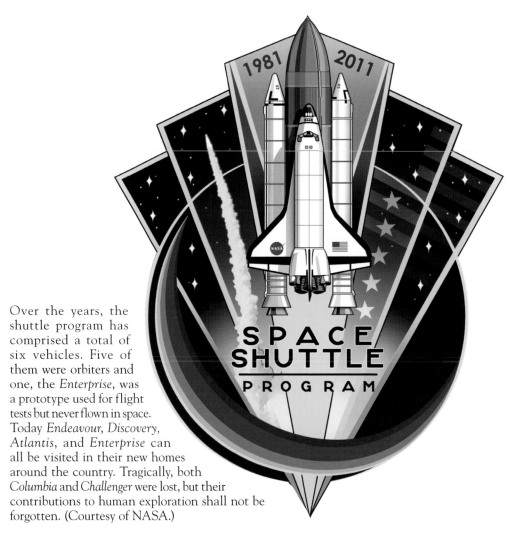

Over the years, the shuttle program has comprised a total of six vehicles. Five of them were orbiters and one, the *Enterprise*, was a prototype used for flight tests but never flown in space. Today *Endeavour, Discovery, Atlantis,* and *Enterprise* can all be visited in their new homes around the country. Tragically, both *Columbia* and *Challenger* were lost, but their contributions to human exploration shall not be forgotten. (Courtesy of NASA.)

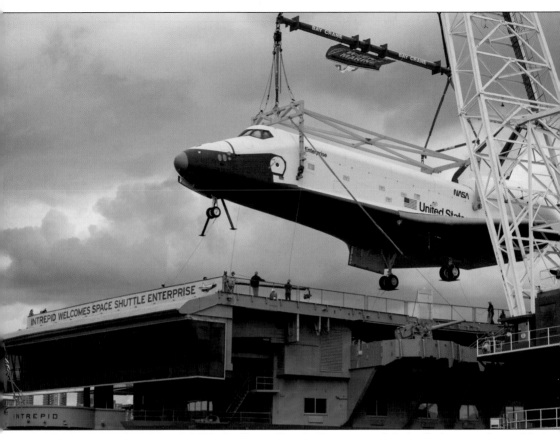

In this image from June 6, 2012, the Space Shuttle *Enterprise* is lifted off a barge and onto New York's *Intrepid* Sea, Air & Space Museum, where it will be on permanent display. (Courtesy of Bill Ingalls, NASA.)

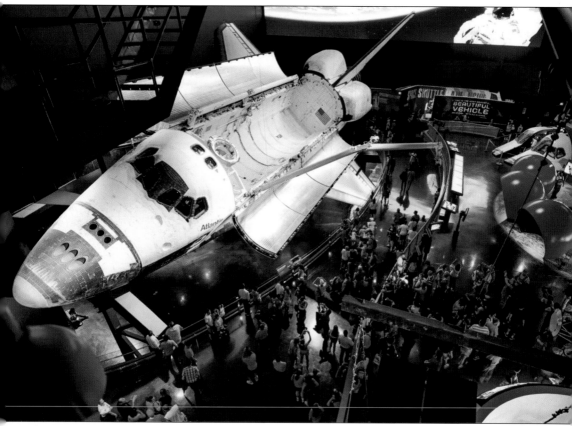

The Space Shuttle *Atlantis* is shown here on display at KSC. *Atlantis* is displayed at an angle in order to simulate how she might look floating in space. Due to the multilevel structure of the exhibit, visitors are able to inspect the shuttle's exterior from top to bottom and look into the open payload bay. (Courtesy of NASA.)

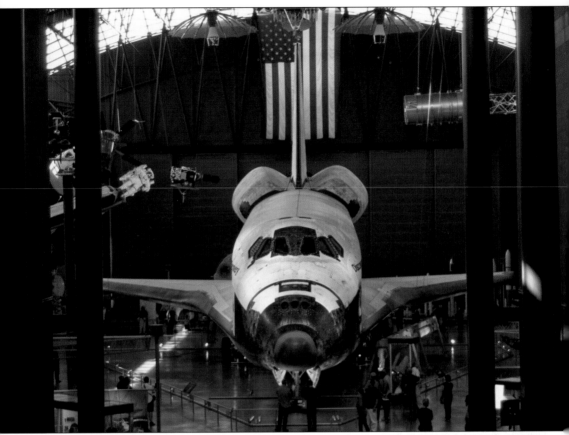

Discovery replaced *Enterprise* in the Smithsonian National Air and Space Museum's Udvar-Hazy Center in Virginia, near Washington, DC. It is currently displayed in the museum's space wing with other space-related artifacts. The Space Shuttle is presented wheels down, as it would look after landing. (Courtesy of NASA.)

Challenger orbits high above Earth on one of her nine missions into space. Tragedy struck during the 10th mission when *Challenger* broke apart only 73 seconds after launch, killing her seven-person crew. (Courtesy of NASA.)

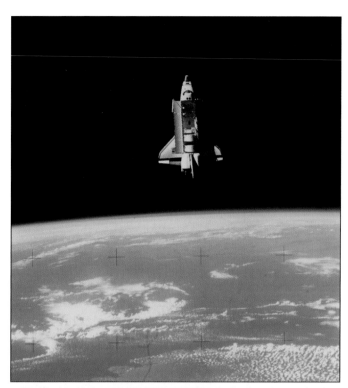

On April 12, 1981, the Space Shuttle *Columbia* became the first shuttle to orbit the Earth. Floodlights reflect on *Columbia* and her service structures as she rests atop Complex 39's Pad A at KSC in preparation for her first launch in this time-exposure photograph. The shuttle would fly for almost 22 years before being lost upon reentry in 2003. (Courtesy of KSC, NASA.)

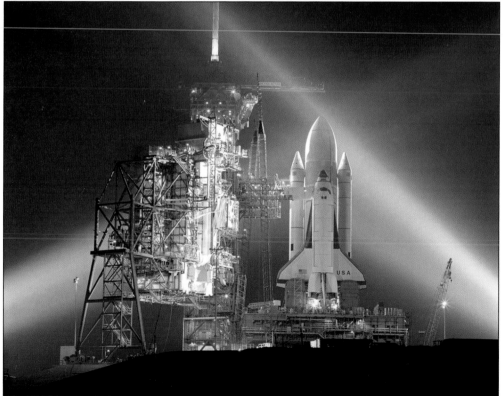

DISCOVER THOUSANDS OF LOCAL HISTORY BOOKS FEATURING MILLIONS OF VINTAGE IMAGES

Arcadia Publishing, the leading local history publisher in the United States, is committed to making history accessible and meaningful through publishing books that celebrate and preserve the heritage of America's people and places.

Find more books like this at
www.arcadiapublishing.com

Search for your hometown history, your old stomping grounds, and even your favorite sports team.